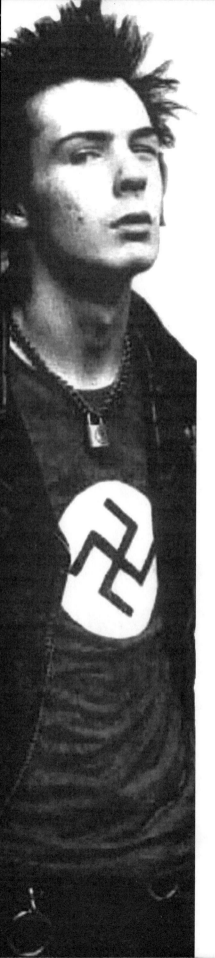

Contents

Introduction	5
Chapter One	9
Chapter Two	15
Chapter Three	21
Chapter Four	25
Chapter Five	29
Chapter Six	33
Chapter Seven	39
Chapter Eight	45
Chapter Nine	49
Chapter Ten	55
Chapter Eleven	63
Chapter Twelve	71
Chapter Thirteen	79
Chapter Fourteen	87
Chapter Fifteen	99
Chapter Sixteen	107
Chapter Seventeen	111
Chapter Eighteen	119
Chapter Nineteen	125
Chapter Twenty	131

Appendix
i)	afterword	137
ii)	discography	141
iii)	legal papers	122
iv)	press cuttings	147

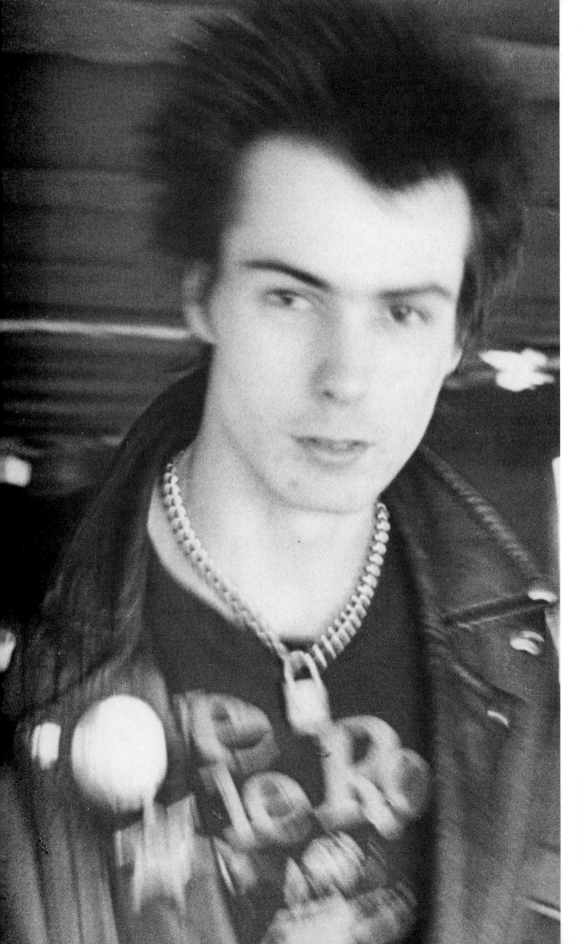

Introduction

Why, you may rightly ask yourself, would I start work on another Sid Vicious book, 14 years after I handed in the draft of my first one? Well, there are a few good reasons; first of all, *Sid's Way*, the original book, was written with the co-operation of Anne Beverley – Sid's Mum. This might have looked like a bonus on paper, but meant that the original draft was way over edited, cutting out everything that didn't show her son in a good light, leaving a book with more pictures than text. This always annoyed me because on tape we had some excellent material that, in effect, we couldn't use.

If you do get the chance (and I for one hope you do) please do check out the following website: www.avpphila.org. It was set up by Nancy's mum, Deborah Spungen, and you'll see why it's important when you get there.

If anything, the real reason behind this book is to clear the name of a man whose records I bought while I was still at school, oblivious to the fact that he rarely played on any of them; a man who, love him or loathe him, died with the word 'murderer' hanging over his head. That's something he not only didn't do but, if half the people I've met in the last fifteen years who knew him are anything to go by, was probably never capable of.

Once I'd been informed that someone else had killed Nancy Spungen and that it could be proved beyond any doubt, I made three different trips to New York to verify the facts. By the third trip, ex-New York Police Department (NYPD) officers were meeting me for a beer supporting the theory – a theory which Anne Beverley had made me aware of before she died.

This project really starts with EMI Records deciding that with the 25th anniversary of Sid's death on the horizon, it was time to release a proper Sid Vicious album, give it some extra material and better packaging. The very week this was decided, I was having a beer with James Williamson, the man behind Creation Publishing. I mentioned the Sid album and he asked if I'd still got all my old Anne Beverley interview tapes. The answer, of course, was yes. I'd also followed Sid's story to Paris and New York, long after the original book. I knew what was coming next. Wasn't it time we had a new Sid Vicious book?...

Yes, the real story is long overdue. If doing the job to meet a tight deadline for the 25th anniversary of his death is what it takes, then it seems like the perfect time.

I've never met Deborah Spungen (Nancy's mother) or any of her family for that matter, although I'm told I once missed her brother David by minutes in a New York deli. I'd just like them to know that I followed this path as much for them as I did for Anne, or any of her family. A friend of mine died some years ago from a heroin overdose. I'd like to think that, had I read Deborah's excellent book (*And I Don't Want To Live This Life*) before he passed away, I might have been of more help.

So, how well did I know Anne Beverley? Simple question: the answer is very well indeed. Did I trust her? Yes. She always seemed very fair in her judgement of people. Did I understand her? I think the jury is still out on that one; at times I certainly thought I did, but on other occasions I ended up wondering. How much do I know about Sid that you haven't read before? Quite a lot, actually. I just think it's time that the whole truth was made public. In one volume.

Am I still a big Sex Pistols fan? After four books – one of which remains unpublished – I'm not sure. Various events of the last few years – notably the Crystal Palace show in 2002 – have left a very sour taste in my mouth. The truth is I sold my rather large Sex Pistols collection in early 2003, although I have held onto a few things, because at the end I just couldn't walk away 100%.

"You are the reason for my laughter and my sorrow, blow out the candle, I will burn again tomorrow." (A simple thanks to those who will know what it means...)

This book will be completed in late September 2003, after which myself and my publisher are taking a trip to New York in December. While we are there, I plan to visit The Chelsea Hotel for one last time just to put a full stop on this part of my life and move forward. The room in which Nancy was murdered, room 100, is no longer in existence. They now have rooms counting 99 followed by 101. If you ever do visit the place be careful not to mention Sid and/or Nancy, they tend to be anything but friendly once you've mentioned those names.

There are a number of people who should be thanked for making this whole thing happen – in the correct pecking order they are: James Williamson (for allowing me to do this); Steve Woof @ EMI (for making it more than a book); Robert Kirby @ PFD (it's

good to have someone fighting in my corner); Lucy Granville (for making the world aware of what I'm doing); Karen @ Planet PR (who was right behind this from the get go); Edward Christie @ Abstract Sounds (for continued faith in me); Chris Charlesworth @ Omnibus (for giving me the chance in the first place); Anne Beverley (without whom the 'reality' may one day have been just that movie); Steve & Martin @ Chrysalis TV (for keeping the flame burning); Jonathan Richards, my editor (who always says "just do it"– for that I thank you); Sil Wilcox @ Cruisin' Music (for helping me get this thing straight); Mark Arnold (for putting faith into it), Keith Bateson (for making it real) and Vicky Mockett (wherever she may be, for making this thing have a beginning).

I should also like to thank the following friends, who have had to live with Sid, not once but twice and who gave their coffee, cookies and advice quite freely. If there is a punk rock afterlife, all of you are on my guest list: Jonathan McCaughey, Mick O'Shea, Uncle George X, Alan Garvin, Incredibly Sexy Kelly, Dave Pearce, Rav Singh, Simon Mattock, Melissa Palmer (the other side of me), Phil Hendriks, Steve Burch, Ian Duckworth, Goz my tattooist (RIP), Phil Strongman, Wayne Connolly, Brian Jackson, Jack Kane, Scott Murphy, Andy Davis, Pat Gilbert, Ellie, Joe Alvarez, Tom & Lee @ Vivienne Westwood, Maz, Little Aussie Ruth, Fi and Paul Burgess.

"I ain't no vision, I'm the man who loves you inside and out, backwards and forwards with my heart hanging out." (Something from within me, for most of the above.)

To my parents and my brother, David – just thank you. This thing took 15 years to come full circle and now it's finally all out in the open. To Jake Burns, Bruce Foxton, Ian McCallum and Steve Grantley – or Stiff Little Fingers to you – thanks for making me feel part of a rock n' roll family...

There are too many photographers to think about thanking each of them individually, but for the record a BIG "Thank You" is due to: Bob Gruen/Dennis Morris/Roberta Bayley/Ray Stevenson/Ian Dickson and everybody at Rex Features Ltd.

If Sid Vicious were alive for his birthday in 2004 he would have been 47 years old and, quite possibly, not long out of one of the toughest American prisons for his part in a murder he simply did not commit. Why do we need another book on him? Easy. It's time to be honest...

Alan Parker, Maida Vale, London, October 2003.

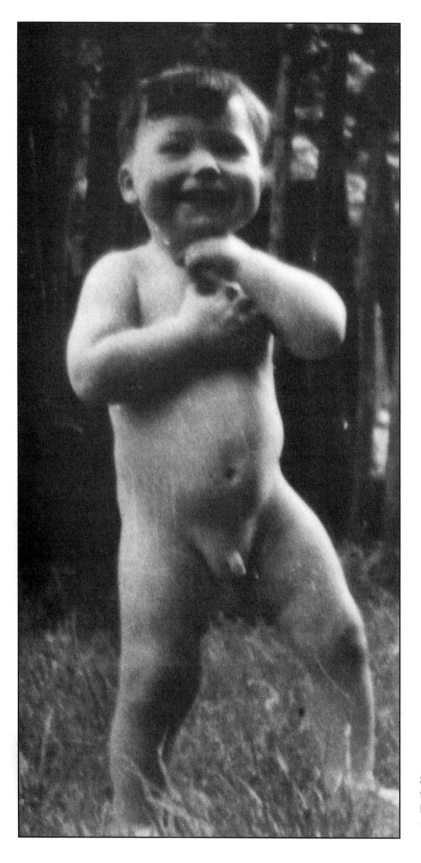

Sid as a toddler c.1960,
fooling around in John
Ritchie's parents' garden
(pic: Anne Beverley).

Chapter 1

I first met Anne Beverley at the back end of September 1988. Originally, I had been asked by her directly to write a book about her son, but at the time I was straight out of fanzines and had just arrived in the world of rock journalism – a paid up member of the team at *Spiral Scratch* magazine. I was scared witless about the idea of writing anything longer than three pages about anybody.

In the last days of *Spiral Scratch*, Lee Wood, the Editor, told me to grab the idea full on and do something about it. So I got back in contact with Anne, who suggested that we meet up and have lunch in Swadlincote. She hated London, too many bad memories, ghosts around every corner. On a Friday afternoon just after lunch, I left for Swadlincote. I wasn't at all sure where I was going so I got the train to Burton-On-Trent, where Anne arranged to pick me up. This meant I had to change at Birmingham New Street – a station that still displayed an old poster that read: 'If You See Sid Tell Him....' from an old advertising campaign for British Gas. I laughed to myself. The adventure was about to begin...

John Simon Ritchie was born on May 10th 1957, but there is only a birth certificate for him. He died some 21 years later, having lived out the dream and become a pop star, but the death certificate issued that same week to his mother was for Simon John

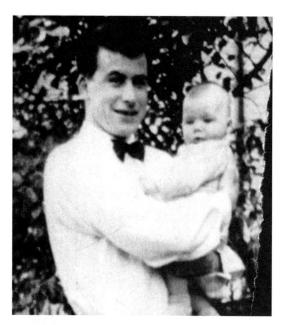

John Ritchie with baby Sid

Beverley who, strangely enough, never had a birth certificate. John Ritchie senior had met Anne Randall while she was serving a very short term in the RAF. For his part, Ritchie was a member of the Royal Guard and had stood guard duty at Buckingham Palace. Although Anne would talk in later years with affection for the RAF, records show that her time in the service couldn't have added up to any more than 2 months. While it's true that John Ritchie did serve at Buckingham Palace, he had moved on and left the services long before 1977, making John Lydon's sound byte in the movie 'The Filth And The Fury' about Sid's father being on guard duty while his son was signing the A&M records deal as little more than nonsense.

This book is not the story of the Sex Pistols. I make no apologies that large chunks of their story is missing from this text; if you wish to know their story there can be no finer place for reading it than *England's Dreaming* (Faber & Faber) by Jon Savage. What I hope to offer here is a better insight into the life of Simon John Beverley.

The myth is that Anne Randall just melted and fell into the waiting arms of John Ritchie, but the fact is that Ritchie was head over heels in love and did a fair amount of chasing, before catching what he thought was his bride-to-be. Anne had left home

Mother and son in Ibiza – with no clue what the future holds...

early, joined the Air Force at the tender age of 18 and married straight away. I interviewed Anne over 20 hours of tape, and never once did she – or would she – name her original husband; all talk was of John Ritchie, who gave her a child, never married her and walked out of her life just as easily as he had walked in 2 years earlier. Almost penniless at the time of their son's birth, John Ritchie hit upon the idea that they would leave London and its problems way behind and start afresh in Ibiza, a whole 30

years or so ahead of the whole 'E'-generation. Anne and Simon, or 'Sime' as he was eternally known to his mother, left for the sun-kissed island with Anne already convinced that the promise of large sums of money, or even John Ritchie joining them, was all just talk. To survive in Ibiza, Anne lived on dodgy credit cards, a large portion of the goodness of others, a little typing for friends and the ability to roll joints for people.

Mother and son returned to London in early 1961. In the past, it's been said that while they were in Ibiza, Simon learned to speak in a foreign language, sang along to Ella Fitzgerald records and became drunk, the very same night that a friend of Anne's predicted he would be Prime Minister. Unfortunately, these were all shots at colouring a better past for her son, an indulgence to a mother full of sorrow and from a writer struggling on his first book.

The problem which first hit them upon their return to London was Anne's appearance. Fashion-wise, the look of the day for women was the beehive hair do and a skirt two inches below the knee. Anne, in contrast, wore a one-inch razor cut hair style with a skirt two inches above the knee or, on occasion, tight jeans. In the middle of Soho, this attracted every lewd and crude passing comment you could ever imagine. Of course, young Simon heard them all.

Anne gave her son a code for life which helped with his image: "You are you, you can do anything you like providing you don't hurt anybody else while doing it. You should be able to do what the fuck you like." At such a young age, she later told me, you could be sure all that went in. The young future Sex Pistol changed school almost as often as his mother changed address or work, but Simon hated the various schools he attended. He finally bailed from Stoke Newington Church Street at the age of 15, totally against Anne's wishes. Long before this he had gone from being John Simon Ritchie to Simon John Beverley. Anne quickly started calling her son Simon, once his father was out of the picture. John, after all, was far too close a reference to John Ritchie.

It was in late 1964 that Anne met and fell head over heels in love with Chris Beverley. Chris was from an altogether different background to Anne, or her family. His lifestyle

was best described as 'a cut above'. Anne told me on our second meeting that meeting him was like winning the pools!

After a whirlwind courtship, they married in February 1965, but before Chris had the time to complete the paperwork needed to fully adopt Simon, he died very suddenly in August of that same year. While the whole episode did hurt Anne Beverley more than she ever showed the world, her front was always to grit her teeth and move on. The reality, however, included late night visits to Chris's grave just to talk to him, to be with him, to try and prove the whole thing was real. She did manage to convince herself that tragedy would no longer be a part of her life and, having faced that fact, could carry on with the business of living her life...

At this point, Simon was taken away from his normal school and with the addition of a nanny – the very same old lady who had cared for Chris Beverley – and the financial help of Chris's parents, he was placed in a private school. On his first day he set a pattern for his time there by declaring that he didn't believe in God. It wasn't that he was an unruly child, but he did like to prove he could shock people. Remember: this is the same child whose nanny later reported he was never happier than when he could sit for hours and play with Action Man at battle. In time, Sid would become an action figure himself.

Things did become a lot more settled at this point. Anne bought her son a bike on HP, which would not only be useful for school but would allow the pair to go riding at weekends. While he was no academic at school, Simon did show a real talent for history. As his mother recalled: "He soaked up every word they told him like a sponge. He would often explain what the history of any part of London was long before you arrived there." He also showed an aptitude for art – if his early sketches and paintings are anything to go by then, had his life taken a different turn, who knows what he might have achieved?

Anne Beverley knew deep down that school was not for her son, so despite wanting him to gain the sort of education she had failed to do for herself, she allowed him to leave school at 15. Simon's first job was at Simpson's, the factory that makes Daks trousers. The rag trade was obviously not for him because he kept getting the sizes

The T-Rex fan at Art College

wrong when he was cutting out the pockets. After no more than a few weeks, he quit. His intentions were now clear – he would go to Hackney College to study art and photography.

Because she loved art Anne was very pleased with his choice. It was at Hackney College that he first met John Lydon...

Chapter 2

The original idea had been that I would stay the night at Anne's place and then leave the following day for Blackburn, in order to see my parents and update myself with all my Sex Pistols books and, more importantly, scrapbooks. But that night over a curry we realised we got on like a house on fire, so I stayed till the following Wednesday. We put together a water-tight plan for the book, *Sid's Way*, which we decided would be told very much from Anne's point of view, as a mother. The following week, I introduced Anne to Keith Bateson who had already promised me that he would be involved in the project. He was, after all, the only writer I knew at that time who could very easily pull together all the conversations that myself and Anne would later have...

"The first time he came round he had hair down to here, a beautiful head. He was shy. If I just looked at him, he went beetroot red. Couldn't say a word. I'd never met someone that shy before." These are the words of Anne Beverley. She is talking about the future king of British punk, John Joseph Lydon and their first meeting. Over the years people have often asked me what Anne thought of John Lydon. The truth is – not much. She thought he was a coward. Every time she saw him on television she'd say: "Here he is, doing a 'Rotten' giving the punters just what they wanted to see. If his love of all those around him is so deep, where was he for his so-called best mate?"

Up until the day Anne Beverley died in September 1996, she never quite understood John Lydon. If he was such a good friend to her son, then where did his speech at the 1996 re-union press conference, held at the 100 Club on London's Oxford Street, come from? All the talk of Sid being a useless coat-hanger, brought laughs from the

The Bowie boy and "Wild Thing"

gathered UK press, but in a small house in Swadlincote later that same evening, they brought tears from a woman who had at least expected that day of all days to pass with her late son's memory intact, or at the very least a modicum of respect.

"The first time I ever met Sid and John they were sat in a squat, rubbing butter into their faces because they thought it would give them spots." (Adam Ant)

By the time Simon met John Lydon, he was obsessed with David Bowie. Every inch of his room at home was plastered with Bowie posters and clippings. Simon had dyed the front of his hair bright red, and cut it spiky and much shorter than normal, although he wasn't using hairspray to spike his hair; this was to be something he later

learnt from John. At this point, he was experimenting with the interesting concept of lying with his head in the oven. Whatever, it worked. John saw him has a poser, interested only in whatever *19* magazine or Bowie record sleeves told him to wear, but whatever it was, he wore it.

The name Sid Vicious came about from the coupling of a hamster's name (John had named his hamster Sid after the crazy ex-Pink Floyd guitarist Syd Barrett) and a Lou Reed song titled 'Vicious' from his *Transformer* LP (co-produced by Bowie), although the second part of the name was added later. "He was a Soul Boy when I first met him," recalled John Lydon years later. "You know the uniform: it could be mid-winter and snowing, but he wouldn't wear a jacket. He had naivety, which is a good quality, a kind of innocence, but he lost that. He couldn't see dishonesty in people. He was funny: he would laugh at everything all the time. Everything would be the ultimate amusement to him."

Giving Simon Beverley the name Sid Vicious did, at least, give him an identity. Finally, his nickname would give him something to base a life on. Recalls Anne Beverley: "He was never in a stable situation, it was like a mirror of my early life." But Sid and his mother were very close. They often seemed like conspirators rather than mother and son. Having left home at the age of 15, Sid lived in a squat for a few months before returning home to three square meals and a bed he could call his own. He loved his mother's cooking, especially her mashed potatoes and her homemade chilli.

The situation was fine for a couple of years. His new-found friends would come around, including Lydon. There was John Wardle (nicknamed Jah Wobble), John Grey (Lydon's right-hand man) and a skinny kid called Keith Levine. Anne Beverley later told me: "Keith was a funny one. I was quite the hippy, certainly in parts of my lifestyle, and after I'd had a bath I never towel dried, rather I walked around and dried off naturally. But for me bath night was always the same night. Eventually it became obvious that Keith was only coming round to pick up Simon on nights when I would be walking around naked!"

Wobble was, by all accounts, the strangest member of the gang. He is best summed up in this story from Glen Matlock: "I was working at the shop [Too Fast To Live, Too

Young To Die] on Kings Road one Saturday afternoon, when in walks Wobble, very high on something, 'Have you seen him?', he asked me. 'Who?' I said. "So he told me he was looking for John Lydon, and I said he hadn't been in yet. Wobble then asked if the fuckin' coppers had been in looking for him. When I said they hadn't, he said 'good' because he had just stabbed a copper to death on Kings Road. I mentioned this to Malcolm, who just laughed. And when the others turned up to join him the subject was dropped."

Another part of Anne Beverley's past was trailing her son and, more indirectly, his friends. Having smoked dope on the hippy trail from an early age, Anne had progressed to speed, onwards to cocaine and finally ended up in the grip of heroin addiction. Indeed, at one time in her life her habit had become so severe that for the rest of her time she would have a piece of needle forever stuck in her left arm.

Steve Severin (later of Siouxsie And The Banshees) remembers that the Sid he first met was not very violent at all. The reality was that John Lydon's gang, which included Jah Wobble and Rambo, both of whom could start trouble in an empty house, had drawn Sid into a much more macho world than the one he truly belonged in.

At the age of 17 and after two more years at home, Sid had finally snapped. One day he and his mother had a massive row. Anne decided enough was enough. "Simon, it's either you or me and it's not going to be me, so you can just fuck off." Sid responded that he had nowhere to sleep and Anne came straight back with: "I don't care if you have to sleep on a fucking park bench. Just go." Years later she would tell me through a stream of tears that she always felt this was a wrong move; it was in her eyes the beginning of the end. Whatever happened next, she would always be the woman who had made Sid Vicious homeless and, by doing so, in her own eyes helped fuel his transformation to icon and, ultimately, martyr.

Sid was right back to square one and living in a squat. As a pretty looking Bowiesque boy, he soon fell into prostitution under the name of Hymie (another to add to his growing list of aliases). He circulated a photograph of himself with a goofy smile with the biro-written words. 'I'm Hymie try me.' In many ways, the die was already cast. It wasn't long before John joined Sid in the squat in Hampstead, the seedy Victorian bit

around the back of the station. They were dwellings rather than homes. Some quite desperate people lived up in these squats by the middle of the 70s. Sid managed to get a job as a cleaner at Cranks health food restaurant on Tottenham Court Road so, even if the wages were very poor, at least the food he could steal or be given meant that they ate better than most in the same situation.

Not long after this and, initially, all in the name of fashion, first John and later the others, discovered the Kings Road. Sid then found out which house Bryan Ferry lived in and told John he was going to just turn up one day with a bottle of Martini in one hand, and not leave till he got an audience with Ferry. Despite thinking the overall idea was a good one, John had got himself into the all too cool position of leader to actually think about carrying the plan out himself. Sid still thought his idea was a good one and if he wasn't allowed in straight away, he could always hang around and make a run for the inside of the house much later. Alas, Sid and Bryan never met.

Sid, it turned out, would be the first of them to discover the shop, a tiny clothes store situated at 430 Kings Road, named Too Fast To Live Too Young To Die. It was owned by Malcolm McLaren and his partner Vivienne Westwood. The clothing line they offered for sale on the inside was anything but normal: rock'n'roll blared out from a jukebox, teddy boy clothes were mixed with bondage and rubber gear, in a space not much bigger than most living rooms. This was much more than any normal clothes shop. This place was exciting...

Chapter 3

The once long and lustrous head of hair as described by Anne Beverley and which once belonged to John Lydon, had been hacked off and dyed green in a bid to shock Lydon's family and play the hero with his friends. This was complemented, for no less a reason than poverty, by a bunch of clothes worn to holes and pinned back together. Among these items was a green Pink Floyd T-shirt which included the newly-scrawled words 'I Hate' above the group's name. With this kind of get-up, it wasn't hard to get noticed on the street, and the busy Kings Road was no exception.

The Saturday lad at the shop, now re-christened Sex, was Glen Matlock, a young Small Faces fan and bass player in waiting. Malcolm, the shop's manager, had been bitten for quite some time by the rock'n'roll bug. Being in the rag trade, no matter how flamboyantly, was never going to be more than small potatoes for him, so he decided upon a brighter future for himself. He would manage a band. If he was lucky they would be the new Bay City Rollers. To this end, he flew to New York on a so-called fashion buying trip. In reality, he was chasing a group who had bought clothes from his shop on a recent trip to London – The New York Dolls, peddling a new kind of sleaze and who had found their way to England to support Rod Stewart and The Faces at Wembley. While they had been in the UK, their drummer had died from a drugs overdose. But they had re-grouped in New York and decided to continue. McLaren saw the manager's role was his for the taking, and while over the years he has told every living soul that he did in fact manage The Dolls, his role with them actually seems to extend to little more than a few photos of the group decked out in red leather costumes, stood before a hammer and sickle flag. But New York did give him a few

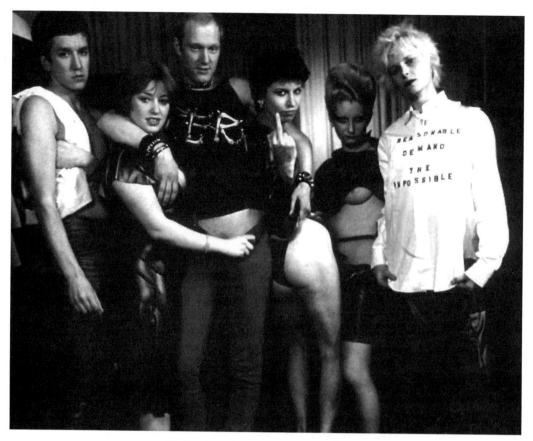

L-R: Steve Jones, Danielle, Alan Jones, Chrissie Hynde, Jordan and Vivienne Westwood – Sex, 1976

ideas. In the Bowery and surrounding areas of Manhattan, something was changing; skinny wasted-looking kids in street clothes were making a new sound: one of them had hacked-off hair and a few pins in his shirt, holding it together. His name was Richard Hell.

Back home in the UK, a set of different kids were drawn towards the shop. Two of them, Steve Jones and Paul Cook, a couple of cockney football fans with a liking for girls and beer, had decided to form a group because it seemed better than any other kind of work, and also because the light fingers of Steve Jones had managed to put together a fairly impressive collection of musical instruments – the most impressive of all this collection being the bulk of David Bowie's backline, stolen while Bowie was performing a three-night engagement as Ziggy Stardust with The Spiders From Mars at the Hammersmith Apollo. Jones and his light fingers had also found their way to Sex in order to steal some new clothes, but the ever observant McLaren had spotted him

way to soon and, rather than give him grief about his actions, decided to befriend both Jones and Cook. The pair mentioned their group idea and were instantly pointed in the direction of Matlock.

By the time Sid had met the in-crowd at Sex, the working unit of Jones, Cook and Matlock were already under the wing of McLaren. Sid, with his cropped almost skinhead cut and larger than life persona, was seen by Vivienne Westwood to be the perfect frontman for the young group, then calling themselves The Swankers. But on the day the call came, Sid was working on a market stall in Portobello Road, so it was decided, via a lot of pushing from John Grey – and a later amount of bullying from Steve Jones – that John should audition for the place of singer in the group. His 'audition' took place in the shop, miming along to Alice Cooper's 'Eighteen' and using a shower head as a microphone. Though by no stretch of the imagination could he be called perfect, he was certainly the nearest they had got to what they were looking for.

Just before this audition was held McLaren, who was convinced that the wasted look of Richard Hell was certainly the way forward for the group under his wing, had taken a trip to Scotland with future Clash manager Bernie Rhodes. The aim was to try and offload some of the very hot gear recently stolen by Steve Jones. During their trip they came across a young and spiky Midge Ure. On sight they offered him the singer's job, only to be told that his own group, Slik, had cut a recording deal with Bell Records just that day. What a different story the Sex Pistols one could have been with Midge Ure as frontman.

Right from the off, there was no love lost between John Lydon and Glen Matlock. The group had originally set up a rehearsal at a pub called The Crunchie Frog in Rotherhithe, but come the day in question, only Lydon turned up. "I called him the next day to say I was sorry," says Glen Matlock. "He said, 'I'll kill you, I will, I'll kill you, I'll come round with a hammer'." At this point Matlock thought... *here we go!*

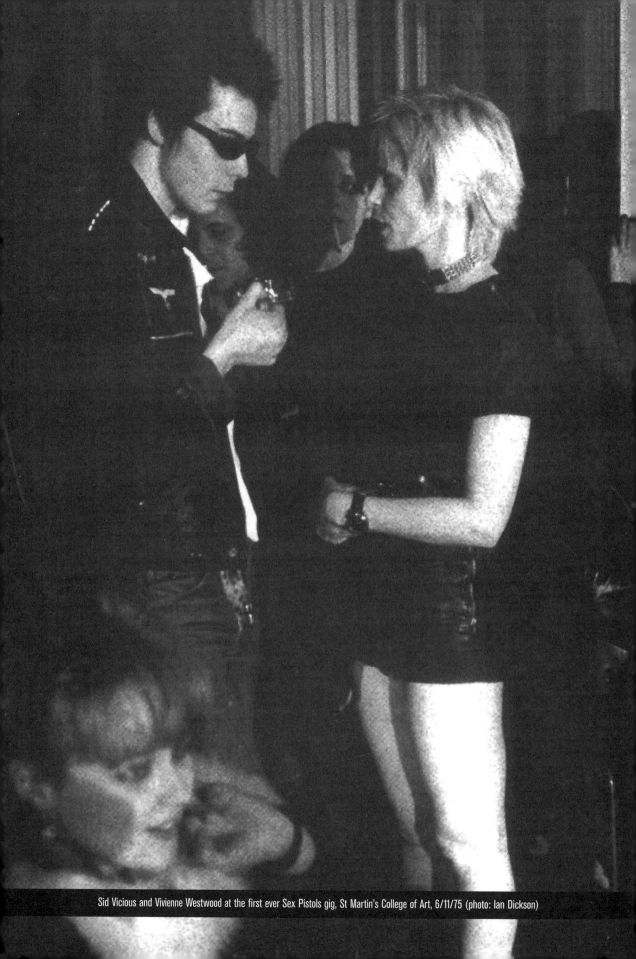

Sid Vicious and Vivienne Westwood at the first ever Sex Pistols gig, St Martin's College of Art, 6/11/75 (photo: Ian Dickson)

Chapter 4

On April 23rd 1976 the group, now under the name Sex Pistols and with Sid Vicious, John Grey and Jah Wobble among their most established supporters, played a gig at The Nashville pub in London. It was in the words of most of those in attendance a fairly average night out, until the group got part way through one of their songs, 'Pretty Vacant'. At this point – and for no logical reason –Vivienne Westwood started slapping a girl across the face; the girl's boyfriend, who was only about three feet away when all this began, walked over to Vivienne and started to punch her from behind. All this was going on right in front of the stage in full view of the group. Malcolm noticed what was happening and threw himself across the guy with fists flying like a windmill. With a look of pure glee, and a sudden fresh interest in the evening, Johnny jumped off the stage and straight into the fight. At that moment in time, violence in this new-found world of punk rock equalled sexy; Sid Vicious licked his lips and jumped in. The event, rather than the gig itself, made all three music magazines of the time with *Melody Maker* running it as a cover story. The revolution was beginning.

One of my favourite Sid Vicious stories was told to me over a coffee on Charing Cross Road, sometime during the summer of 1998. It concerns a reporter arriving at Heathrow Airport from New York in October 1976. Upon passing through customs, he came across a kid decked out in torn clothes and safety pins. His first question was a simple one: "Where can I find Sid Vicious?" Remember, this was a full two months before the Bill Grundy show, a total of five months before Sid would ever really become famous and already he was being asked for by reporters from the other side of the Atlantic.

His non-rock star outlook towards the whole thing might help point out why that happened. This was the man who once said: "You just take a chord, go twang and you've got music." Equally, when asked about the man in the street, he once answered: "That doesn't matter. I've met the man in the street... and he's a cunt."

Anne Beverley pushes herself back into her chair, takes a sip from her can of lager and offers me another spring roll from a Chinese takeaway. It's around midnight and we've just finished watching *The Great Rock' n' Roll Swindle* for about the 26th time. "The problem is, you know, that so much about Simon's early life in the punk world is lost, bits of half stories, something said in a bar one night, and passed on over the years, via another dozen bars. The truth is an awful lot simpler. He did have a girlfriend for a short time. He was with Viv Albertine [later in The Slits] and he was very tight with Mick Jones [later of The Clash]. They all wanted to be in bands. At the beginning it seemed like one big pipe dream, then Rotten joined the group. From that point on anything was possible."

One night at the 100 Club – an old jazz cellar, still active in live music to this day – the Pistols played a gig in front of a number of music journalists and record company people. Among the audience that night was Nick Kent, a later reformed junkie journo but a downright enemy in the eyes of McLaren and Rotten. Sid Vicious, legend would later have it, attended this gig with a purpose. Wound up on speed and out to prove himself with Wobble, Sid stood behind Kent near the small stage. Nick Kent was aware of Sid Vicious, he knew him by reputation. During the gig, Sid tapped Kent on one shoulder. Could he move please because Sid couldn't see. So Kent moved. Only to have the whole thing repeated by Wobble. Upon moving again, he was right back in front of Sid. Kent was then informed that Sid didn't like his trousers. This was followed by the removing of a bike chain from his own jeans and a lashing out at Kent, while his friend Wobble jumped around brandishing a knife and screaming something about cutting Kent's face.

The one lash from the bike chain that did make contact with Kent did draw quite a bit of blood, but, by Kent's own admission, didn't hurt too much at all. Sid was quickly removed from the situation by club owner Ron Watts. Nick Kent was then spotted by

Vivienne Westwood who came straight over and delivered the following statement: "Oh God, that guy's a psychopath. He'll never be at one of our concerts again, I promise that. It's not our fault, we're so sorry." About a month later, Nick Kent went to see The Ramones and in the audience he saw Vivienne Westwood. Pogoing around next to her was Sid. Once again Vivienne came over, but this time she told Kent: "You can't handle violence; you're just a weed."

Around this time, journalist Kris Needs remembers being beaten badly by a bunch of Teddy Boys because of his punk image. The beating was getting worse when suddenly out of nowhere came Sid Vicious, armed with half a brick. He whacked one of the Teds around the head with it and told Kris just to run. To this day Kris is convinced that Sid saved his life.

Anne Beverley remembers: "The biggest problem was the Teddy Boys, I'm not saying that Simon or any of the other punks was a saint, youth will be youth, but these Teddy Boys were awful; they hunted in packs of at least six, only picked on smaller groups, would very happily pick on punk girls and quite often ran a mile when the punks turned on them."

Sid almost got the job of lead singer with The Damned, spotted one day in a silver blue jacket (originally owned by John Rotten) by Rat Scabies and Brian James, who instantly invited him to audition for their group. In fact, it was a close-run thing between Sid and a young grave digger turned vampire punk, named Dave Vanian. On the day of the audition, Sid didn't get out of bed in time and so the course of UK punk took another different road.

Chrissie Hynde (later of The Pretenders) also used to work at the Sex shop, but she was staying in London and working without a visa. She hatched a plan in order to stay in the country and form a group: she would get married. Her deal was fairly simple – she would pay someone to marry her. Sid was chosen. On hearing that it was paying work, Sid was right up for the job but, on the day of the proposed wedding, he failed to show up.

Anne Beverley: "My next door neighbour here in Swadlincote gets more mileage out

of it [Sid's fame] than I do. I know for a fact that every Friday morning she's in the queue down at the butchers' and somewhere in the conversation, she'll find a place to drop the news that she lives next door to Sid Vicious's mum." At which point, I laugh. "Still," she continues, "he couldn't have looked after his old mum any better if he'd been the manager of the local bank." That got me thinking. Anne received about £125,000 per year on worldwide Sid product, lived in a lovely little cottage way off the beaten track, never had to deal with anyone face to face – and yet her son was punk rock's Public Enemy Number One...

Chapter 5

"SID VICIOUS MIGHT WELL HAVE INVENTED THE POGO, BUT HE WOULD HAVE BEEN THE LAST PERSON IN THE WORLD TO TAKE ANY CREDIT FOR IT."

(NILS STEVENSON)

The inner circle of all the gang at 430 Kings Road, from the group to their followers via the actual kids who worked in the shop, were by now playing with fire, albeit a fire set right at the beginning by Malcolm McLaren and Vivienne Westwood. Drugs had become a big part of life for some very unstable teenagers; and if anybody from this group had taken to the lifestyle chapter and verse it was Sid Vicious. He was by now hooked on speed and, to all those around him, had become Viv Albertine's toy doll: "We'd go to the shop and Vivienne would just put a pair of trousers on him, he was like a toy almost," she recalls.

Anne Beverley unfolds a piece of paper. It contains some words written in pencil to a song called 'Belsen Was A Gas'. This was not the first song ever written by Sid Vicious, but it was certainly the first song ever written by Sid that would eventually be recorded. His previous efforts have all turned up at auction over the years and seem to add up to nothing more than a few lines, the odd good idea left and never returned to. 'Belsen' started out life with The Flowers Of Romance, a group named by Rotten, and featuring Sid on lead vocals, with various people including: Viv Albertine, Sarah Hall, Keith Levine and Palmolive.

They never played a single gig, were certainly the beginnings of The Slits, recorded

Belsen Was a Gas

Belsen Was a gas,
I read the other day,
About the open graves,
Where the Jews all lay.
Life is fun, and
Wish you were here,
Was what they wrote on post-
cards to who they held dear

CHORUS

Belsen was divine.
If you survived the train
Then when you get inside,
It's Aufieder Sein.

nothing, fell apart from time to time and are mentioned in almost every punk book you will ever pick up! One night at the squat they called home, Viv went to bed and left Sid up with a bass guitar. He took a lot of speed and stayed up all night playing along with the first Ramones album. By the next morning, he had the hang of the bass guitar and though he would never be in the same league as, say, John Entwistle, he now had the first stirrings of musical aptitude.

Anne Beverley: "Let me tell you about The Flowers Of Romance. They certainly all seemed very keen. It started because all of them wanted to be in bands, although from what Simon told me, even after their first day together it looked very obvious like

they would never stay together, but for him it was very much something to be doing until something better came along. He would always come home to see me very excited, everything was going to happen there and then. He wanted to be recognised like Bolan or Bowie. For him it was about fame on a high level."

In the early part of 1990, someone called my mum's house from Coventry. The caller claimed he knew where I could get hold of a rehearsal tape of The Flowers Of Romance for 500 pounds. I rang Anne just to confirm that no such tape had ever existed. She said that there never was one, but it would be cool to see what the guy was offering. I asked him to send a tape of just snippets from his recording. Three days later a cassette arrived featuring short snips of 'Belsen' and 'Chinese Rocks' – they were taken directly from the Virgin album *Sid Sings*, but taped straight across a room with people talking across it. Anne said 'good luck to him' and I dropped the tape into the Trent.

Sid was very much the leader of The Flowers. He talked them all through what they would need to wear to be a part of the group, largely all leather, mostly black, but some pink (for the girls). Everything was to be purchased from Sex. He told them all that Vivienne had promised there would be a bulk discount for members of his band. But the truth was the only person in the group who saw anything like a discount was Sid. In fact, it was very rare that he would ever pay for anything. Nils Stevenson told me: "I remember Sid telling his band mates that they were on some kind of Vivienne endorsed discount scheme. They would all troop in quite happily, pick out some clothes, take them over to the counter and then realise that everything was full price. No favours on the cards."

Sid's situation was never very easy for others. He was totally bored with day to day life, so he would do all he could, initially with the speed, to drown the whole daily routine thing out. He would always just come out and claim total ignorance if he didn't understand something, which made him difficult to confront and had an uncanny ability to change his mind about an opinion – even half way through a conversation. He had only been named Sid Vicious by his friends, but once he got the name, he decided to live up to it on a daily basis.

Sid shares a joke with Paul Cook at the first Pistols gig

Anne Beverley: "He had never been a part of the gang, always something of a loner right through school. People did come around but I wasn't aware of a single name, they all just came and went. But the punk scene was a bond for him, a reality. Suddenly, I knew everybody by name, suddenly his world was full. I always got the impression that from day one of the punk scene, he felt very much like he belonged."

Chapter 6

With a keen eye on the amount of money punk rock was bringing through the door, Ron Watts (the manager of the 100 Club) decided to put on a punk rock festival, the first of its kind in London. The whole thing would be held over two nights, kicking off on September 20th 1976 with the Sex Pistols headlining and continuing on September 21st with a bill including The Damned and The Buzzcocks. The first night would also include the debut performance of Siouxsie And The Banshees, a group formed quite literally at the bar of Club Louise, a famous punk hang-out. Malcolm McLaren had suggested one night at Louise's that another group was desperately needed for the punk festival and Siouxsie, who just happened to be present, chipped in that she had a band. The following day Siouxsie, whose 'band' now had a gig, organised a rehearsal bringing in her friend Steve Severin on bass, Billy Idol on guitar (who promised to be part of the new band and then vanished without trace till after the festival), Sid on drums – largely because he had said he would help out any way he could – and, finally, in the absence of Billy Idol, Marco Pirroni on guitar, who they knew via a mutual friend, Sue Catwoman.

The name of the group came from a TV screening the previous evening of the Vincent Price horror flick *Cry Of The Banshee*. The first performance of Siouxsie And The Banshees, however, was no dream gig. At a rehearsal the day before over in Camden, at The Clash's rehearsal room, it was decided unanimously that there was no point in trying to learn any songs because everyone was off in various directions. The Banshees had originally planned to use The Clash's equipment and backline for the gig, until Bernie Rhodes (The Clash manager) saw that Siouxsie was wearing a

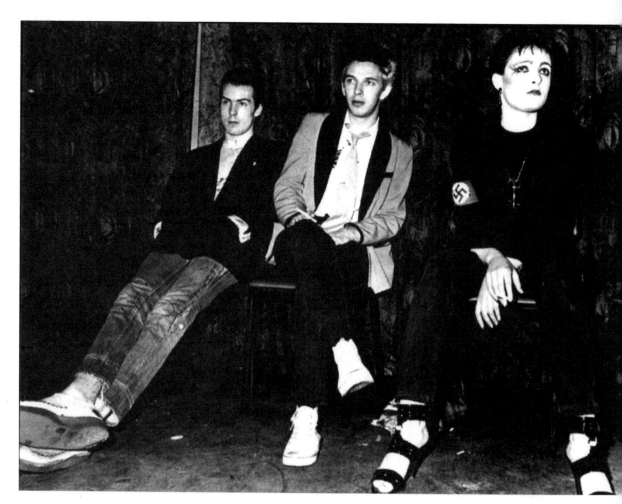

L-R: Sid, Severin, Siouxsie – just before soundcheck, first ever Banshees gig

swastika armband and Sid had a swastika daubed on his T-shirt in black felt pen. Rhodes, being Jewish, decided that this was not the sort of association The Clash needed and pulled the offer, but the Sex Pistols came to the rescue (in the world of McLaren, what was a swastika between friends anyway?) and the gig went ahead.

Anne Beverley: "The myth is that Sid left The Flowers Of Romance to join The Banshees, but this was not the case at all. He simply did something to help his friends. That was, after all, him all over."

The Banshees opened their first ever gig with something that years later Marco Pirroni would describe thus: "We did a Velvet Underground thing for what seemed like hours

and hours, it was horrible: Sid was doing Mo Tucker. I was doing 'Sister Ray'. I remember me and Sid looking at each other and we were fed up, so we just stopped."

Those present remember something long and strange, a bit like The Velvet Underground meets 'Smoke On The Water'. Their set included bizarre versions of songs by The Beatles and Bay City Rollers, played at feedback level, to a stunned crowd, with the now legendary version of 'The Lord's Prayer' to a backing of something that sounded a bit like 'Knocking On Heaven's Door'. By the end of the evening a new band was born, though one that would go through serious rehearsals and line-up changes before it ever made another appearance. Sid Vicious had finally appeared live on a stage in front of an audience.

"If the first night was about seeing Sid play live for the very first time, then the second night was to set the name Sid Vicious in stone more than anything that ever happened

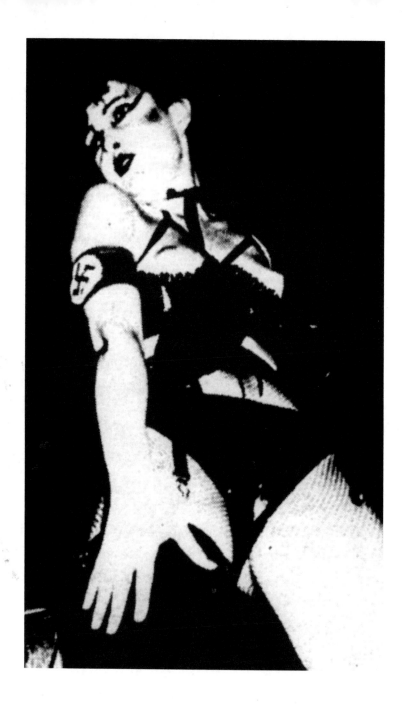

between him and Nick Kent. This was the night when the stuff of legend was born."
(Nils Stevenson)

Violence-wise, all had gone well at the first night of the 100 Club punk festival. The
usual hollering and cheering, some banter between mates, but all in all nothing to get
worried about. The second night was a different story, with a bill that looked like it had

been pulled together in desperation just to make the whole event run to two nights – which was the truth – and included a French band nobody cared about (The Stinky Toys), a pub rock group who had spotted the bandwagon marked punk and taken their jeans in (The Vibrators) and, as the final insult, a group managed by McLaren's arch enemy, Jake Riviera, and hated with a passion by the management at Sex. Vivienne had sometimes banned people from the shop just for daring to speak their name, yet here they were headlining – and they were The Damned. During a cover version of '1970' by The Stooges, someone decided to show just how much they were loathed by the movers and shakers of this new scene. A beer glass was thrown at the stage, but the flying missile missed its target and smashed on one of the club's concrete pillars. It showered a section of the audience in glass and one girl caught a splinter in the eye. Sid was later pulled from the crowd by police, along with journalist, Caroline Coon. He was taken to a police station and beaten badly during the journey.

Sid, by now a child at the feet of McLaren and Westwood, was forced into a situation where he would be encouraged to push all the boundaries. He had been at the forefront of the violence at The Nashville and the attack on Nick Kent at the 100 Club, but all this was little more than bravado in front of the woman he so wanted to impress – Westwood, the clothes shop owner who made him feel like part of the family. As a sideline to this, if punk ever needed a figurehead it was quickly gaining one – a youth who had once been a loner was fast fitting in with the new regime. It is now generally accepted between all those present at the second night of the punk festival that Sid did not throw the glass; more likely it was thrown by a kid new to the scene and out to impress his mates, but it gave the burgeoning Sid Vicious legend some very damaging extra mileage.

Despite not doing the crime, it was Sid who was called upon by a court to do the time. Within a week of the incident, he was locked up in Ashford Remand Centre. It did change a few things for Sid. First of all, he decided to dedicate the rest of his life to total personal freedom; secondly he had the time to read a book on Charles Manson – a gift from Vivienne. What he took from that publication would stick with him forever. Finally, he took the time to write to a few people – Viv Albertine, Vivienne Westwood and his mother. Most of the letters already mentioned in other books talk of agitation and the most awful nightmares.

Anne Beverley remembers: "He told me not to visit him because the other lads would think he was a mummy's boy. He said the violence dished out at Ashford was very real, nothing like the cartoon violence spoken about all the time by the others, though who 'the others' were I never found out. I cried myself to sleep with some of those letters. Looking back on it now, it marked the death of Simon and the birth of Sid, but at the time I buried that; I didn't want to think about it."

The upshot of the whole 100 Club incident was that punk bands, including the Sex Pistols – who weren't even in London that night – were barred from ever playing the venue again. The club that had helped spawn punk was now already calling time on the movement...

Chapter 7

After his stint as drummer in Siouxsie And The Banshees – and via his time at Ashford Remand Centre – Sid went straight back to being the front man of The Flowers Of Romance, although this second stint seemed to be far more about taking drugs and hanging out with mates than actually making any music. They also recruited Steve Walsh to their ever-changing line-up, although in hindsight this was just something to do before the girls grouped together and formed what would become The Slits. Beyond 'Belsen Was A Gas', further songs that would never see the light of day in any format were written by Sid. They included: 'Brains On Vacation' and 'Piece Of Garbage', which don't seem to add up to much more than a few lines of scribbled lyrics each. Very much in the punk rock/blank generation style with echoes of The Ramones, who had fast become Sid's favourite band.

Anne Beverley: "He got really into comic books while he was away. He'd have piles of *Spiderman*, *Hulk* and *The Fantastic Four*. Then, later, it was all *Mad* magazine, which he thought was hilarious. He liked the bit at the beginning where they would really go for it and take the piss out of some new movie, like the latest blockbuster, because he never really liked movies. He thought they were all very boring, something of a waste of his time. But the comic books he loved."

Steve Walsh felt that a lot of Sid's hardman image was very overplayed. If there was a serious punch-up and it looked like someone might get hurt, but the numbers were fair, he'd stay away. But if he could stab someone in the back and run like hell, then he'd be cool about it. At the same time, if a friend was in trouble and Sid could see he

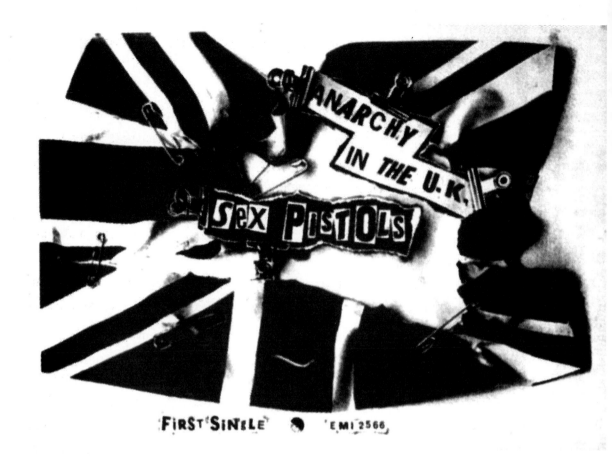

FiRST SiNGLE ● EMI 2566

was about to get knocked into next week, he'd be first in to defend the mate. It was a very child-like way of playing the hardman. Although Nils Stevenson once told me that Sid didn't care about the hardman role at all, but seemed to think (out of some bizarre commitment?) that he had to look the part when John Rotten was on hand.

Anne Beverley: "John Rotten was the big chief, he was a strange choice of leader in that he might well be the first to tell everyone to jump off Tower Bridge, but come the time there was any jumping to be done, he'd be the last one in the queue. He seemed to spend most of his life hiding behind Steve English or Rambo, who were both genuine hardmen and both up for a fight what seemed like 24/7."

Meanwhile, back in the Sex Pistols, all was not well. Continued bust-ups between John Rotten and Glen Matlock weren't helping the situation. Add to that the unbreakable bond between Steve Jones and Paul Cook, pour in a little of the ongoing

problems between John and Malcolm, stir well and stand right back. It was a situation that was unworkable and untenable.

However, having signed a recording deal with EMI Records, the group had issued a single, 'Anarchy In The UK', which was making its way up the charts, thanks to constant gigging and the large amount of press the group seemed to attract. Then, on December 1st 1976, something happened that would change everything. Over at EMI, Eric 'Monster' Hall (then head of press) was faced with the fact that Queen would not be able to appear on the 'Today' show – a London-wide live news/magazine programme – because Freddie Mercury had gone down with a cold. The primetime TV spot was just too good to turn down, so Hall decided that rather than cancelling he would call the studio and simply replace Queen with another of his artists: in this case, the Sex Pistols.

Hall took no time at all in talking Thames Television into taking this hot new band, so by mid-afternoon, the group were in a limo and off to the Thames television studios. After make-up, a simple enough process where they were powdered down for the shine, they headed straight to hospitality. Here, free food and, more importantly, drink was laid on for the guests. Steve Jones helped himself to whatever was on hand, while the show's host, Bill Grundy, seemed to favour a liquid lunch every day. At just after 5pm, the group were ushered into four chairs facing Grundy with a number of their fans/hangers on stood behind them (Siouxsie was among them). In the interview that followed, and via three 'fucks', two 'shits' and a lone 'bastard', the group made the front pages of every national newspaper the next day, and took punk rock from a small, almost self-contained London-based movement to a countrywide phenomenon. From December 2nd 1976 onwards, groups formed across the country and the Sex Pistols were now truly Public Enemy Number One.

Anne Beverley: "Sid, like most of the nation, watched the Grundy thing on TV; it made him laugh, he knew it was coming, the whole thing hadn't been planned but you just knew by that point that the last thing you would ever do with a group like the Pistols is put them on live TV. They were ready to explode. I remember the next day Sid told me, 'This is just the beginning mum, it's all going to take off and be bigger than ever'; "and I thought, well, great; at least his band might get to be a part of it all. Little did I

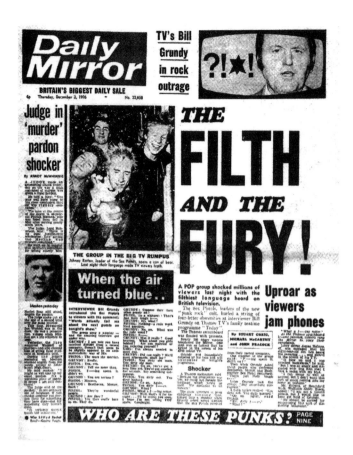

know what was waiting around the corner."

What should have been the 'Anarchy In The UK' tour was due to run through most of December, an idea brought together by Malcolm McLaren and Bernie Rhodes. It combined the Pistols with The Clash, The Damned and Johnny Thunders' Heartbreakers (from the USA). The idea was to take punk to the masses. But the 'Today' show kind of put paid to that idea. Within a few days of turning the air blue, the group had found their tour in tatters, banned from everywhere. They sacked The Damned and marched on through the few towns that would have them. Within weeks they were back in London, cold and skint with the situation between John and Glen stretched to the limit and a record company that was making ready to drop them because this was the sort of publicity a multi-national like EMI just didn't need.

By the early part of January 1977, the problems just kept on growing. Glen believed all the press was going to John's head and John believed Glen was just some Beatles-

loving mummy's boy. McLaren – as 'manager'– did nothing whatsoever to help calm any of this growing storm. Glen knew that the powers that be over at EMI had already seen his worth as a songwriter, so he made the decision to bail, and put together his own group. McLaren decided to send the *NME* a telegram claiming he had sacked Glen because he loved The Beatles too much. Behind the scenes, Glen was paid two thousand, nine hundred and sixty six pounds and sixty eight pence (the supposed sum total of his earnings!), and all was set to employ a new bassist.

SeX PiSTOLS

in concert with

Gen.Foulkersweg 74 Wageningen

UNITAS

the **HEARTBREAKERS**
donderdag 3 februari
Aanvang 9 uur. Kaarten 6,-. Voorverkoop
op UNITAS.

Chapter 8

The Flowers Of Romance was fast amounting to nothing. The straw that would finally break the camel's back was on the way. Because he thought she wasn't committed enough to the cause, Sid sacked Viv Albertine. Upon the delivery of this news, the first line-up of The Slits was born with Sid effectively throwing himself out of his own band. But none of this mattered at all because fate had already played all four of its ace cards in one move: John Rotten had decided that Glen's replacement in the Sex Pistols would be Sid. On the one hand, it made lots of sense – they were mates and it would even up the whole two gangs of two thing, against Steve and Paul. On the other hand, it made no sense whatsoever. What Sid knew about really playing a bass guitar could quite easily be taught to a child in one afternoon. He was, of course, mad keen, but surely he was far better front man material?

Anne Beverley: "The Pistols were leaders of the movement and, to be fair, Sid was their biggest fan. If they had kept Glen and decided they needed a violin player, he would still have joined them at the drop of an hat. But if I had a pound for every music business executive I've spoken to before and since his death, each of whom said he should have been a singer, we'll, let's just say I'd be a lady with a house full of pounds!"

Sid officially joined the group on March 3rd 1977, although his first official duties as a band member would take place on February 13th when he did a USA telephone interview with Rodney Bingenheimer, who wasn't aware that Sid wouldn't join the group for another month. Steve and Paul, who knew what they were letting

themselves in for, did mention that it might be worth giving Paul Simonon of The Clash a try out too, but nothing came of this. John had spoken, McLaren had seen the pound signs and Sid Vicious was in. But in to what exactly? A rock'n'roll band with the worst reputation in the country, with little or no chance of any UK live shows and now without a recording deal – having been dropped by EMI in January.

Leee Black Childers – who had been a good friend to Sid, even offering to manage The Flowers Of Romance despite all his own problems with The Heartbreakers – always thought Sid made the wrong move. The Flowers in their own heads-down-1-2-3-4-Ramones-meets-The Pistols-via-The Clash way could have made it, and if it meant just sticking it out for a while then, why didn't they?

But the group wasn't the only new thing in Sid's life at that point.

McLaren had booked The Heartbreakers onto the 'Anarchy' tour because he knew them – well, two of them anyway. He had tried to get The Ramones for his American act, but they wanted equal billing, which didn't fit very well around the masterplan, so he got himself The Heartbreakers: a four-piece group hooked to the teeth on heroin via the toxic twins Johnny Thunders and Jerry Nolan. They can be 'credited' with having brought heroin to the UK punk scene, but despite their challenges to the younger English punks that they were pussies because they didn't do the drug, everyone on the scene stayed well away. Even Sid with his speed and his tablets was not tempted by the image of Johnny Thunders brandishing a syringe in front of his face and claiming he would only be 'a man' if he took it.

But, as with all groups, there will always be groupies – and The Heartbreakers had their own class of super-groupie. In particular, their drummer Jerry Nolan had Nancy Spungen. Nancy was a stripper-cum-prostitute from well-to-do Jewish stock, a kid from a good family who went off the rails at a very early age with a brother and sister who survived her to prove what might have been. Along the way Nancy had picked up a heroin habit and a compulsion to tell everyone she ever met just how well she knew Debbie Harry. When rock'n'roll entered her life, she became the groupie on hand, happy to trade a blow-job for smack and always in way too deep.

She found her way to England on The Heartbreakers' coat-tails. Once Leee Black Childers knew she was in town, when he ran into her by chance just off Carnaby Street, he told her in no uncertain terms to "Go away. Leave England". Nancy he knew of old. He knew she was no good for Jerry Nolan and he knew she had been telling everybody since she was 15 that she wouldn't make 21. Realising quite quickly – even by Nancy's standards – that Leee was going to keep Jerry off limits, Nancy via her new found friend Linda Ashby (a prostitute and fully paid-up member of the Pistols inner circle) decided that The Heartbreakers were yesterday's news anyway. It was high time she got herself hitched to a Sex Pistol.

Nancy's first port of call was John Rotten, who wanted nothing to do with her or her drugs and passed her on to Steve Jones who, by now, had a reputation as the man who would screw anything. He did just that with Nancy and then moved on to the next girl in the queue. But not before introducing her to Sid. This would prove to be a bad move: a one-night stand turned very quickly into a full-blown relationship because, in his own eyes, Sid now finally had someone special in his life. And Nancy, becoming 'someone special' overnight, wasn't about to spoil it or lose her rock star boyfriend by telling him any different. When Leee Black Childers heard the news, a cold chill ran down his spine. This could only end in tears. He just had no idea how many...

Chapter 9

"I CAN'T TELL YOU THE NUMBER OF TIMES I'VE SIMPLY THOUGHT TO MYSELF, WHY ME? WHAT WAS IT THAT I DID TO PUT MYSELF RIGHT AT THE CENTRE OF ALL THIS? ALL I KNOW IS THAT FROM THE MINUTE SID MET NANCY, EVERYTHING CHANGED; HEROIN WAS NOW THEIR DRUG OF CHOICE BECAUSE IT WAS HER DRUG OF CHOICE. I CAN'T DESCRIBE IT ANY BETTER THAN SAYING, IMAGINE WHAT YOUR WORLD WOULD BE LIKE IF SOMEONE SHOOK IT UP, THREW IT IN THE AIR AND THEN GAVE IT BACK TO YOU WITH NO MENTION OF WHETHER IT WOULD WORK THE SAME AGAIN. THE WORLD GAINED A SEX PISTOL. NANCY GOT A ROCK STAR BOYFRIEND AND I LOST A SON. IS THAT WHAT PASSES FOR A GOOD DEAL THESE DAYS?"

(ANNE BEVERLEY)

The one question about Anne Beverley I've been asked more than any other over the years, by Pistols' fans and friends alike is: did she cry for Nancy? Well, let me put it this way. I saw her cry a lot of tears for Sid but I saw her cry twice as many for Nancy. If there was one thing Anne had a lot of practice of over the years, it was manning the emotional barricades. She never saw herself as a blameless victim, but neither did she deserve what fate chose to leave her.

John Rotten had fought to get his friend into the group, then before they could do anything to be a group, before they even got a recording deal, his friend met Nancy – the girl who would drive a wedge right through the middle of whatever friendship they ever had. McLaren's next job, meanwhile, was to hook the group up with a new recording deal, so that the highly bankable Sid Vicious myth/icon could be truly exploited. Virgin had been calling him since before they were dropped by EMI, but

McLaren saw the roll-neck sweater world of Richard Branson as little more than home of the hippies and, anyway, despite what had happened at EMI, CBS and A&M were still returning his calls. So, there was hope of something better than Virgin on the horizon. After some discussions with CBS, who were very obviously more keen on The Clash, McLaren gained the trust of Derek Green – the head of A&R at A&M Records, UK.

Derek Green fast became the man McLaren was looking for; he talked all the right money, had the full backing of the American side of the company and did seem to know what all this punk rock thing was about and, more importantly, what the Sex Pistols were all about. Green really didn't understand why EMI had dropped the group. He knew the Bill Grundy affair had made a few waves, but boys will be boys and, after all, why couldn't they have ridden the storm? The rest, of course, he didn't know – and McLaren was in no rush to tell him anything. In fact, he was playing Green demos featuring Glen Matlock, showing him photos featuring Glen Matlock and making a deal for a band that included Sid Vicious – a little secret Green wouldn't be party to until the ink on the contract was dry.

Jerry Moss, the head of A&M, USA, was the only man now needed to make a decision and sign off on the deal. Malcolm saw his chance and gave Derek Green a long-winded story about CBS and how they never stopped calling him, then jumped on a plane with his lawyer, Stephen Fisher, and flew out to Los Angeles to see Moss personally. This is called 'playing the game from both ends'. While he was out in the States, he also put his old friend Rory Johnson in charge of Sex Pistols USA. It was also during this trip that Malcolm had the idea of a Sex Pistols movie which, in effect, meant that from this point on, his attention was not first and foremost on the group, but on a film made in their name and, more pertinently, their likeness.

Heroin addiction was turning Sid into Mr Unreliable – it was also kick-starting all kinds of illness. His aptitude for the bass was, at best, second rate and hung totally on the one night in the squat when he had taken lots of speed, stayed up all night and 'played' straight through. At best, he knew one riff, but he knew it very well – good enough, in fact, to play it straight through every song without stopping. And that had better be what the Pistols were looking for: because that was all they were going to get.

The Sex Pistols signed with A&M records on March 9th 1977, a low-key affair carried out at the offices of Rondor Music, A&M's publishing arm. But the next day they did a fake signing, one to boost the PR on their first single for the label. The single was called 'God Save The Queen' adapted from an older Pistols number called 'No Future'. The very public signing of the group took place outside Buckingham Palace, first thing in the morning of March 10th 1977. Derek Green, by choice, didn't meet the group until they rolled up outside the Palace. He was by now hand in glove, or so he thought, with the manager he had cut the deal through: a two-year deal worth seventy-five thousand pounds per year, based on a singles deal rather than an album.

Picture the scene: Sid was stood in front of Derek Green, while the A&R chief was still looking for Matlock. The four Pistols were taken by limousine to the Palace at 9am. Our heroes were still drunk or hungover, or both, from the celebrations of the previous day. They arrived, flicked a few V-signs, swore a lot, signed the fake contract and then jumped back into the car to be whisked off to The Regents Palace Hotel in Piccadilly Circus. There a press conference was held, attended by pretty much every magazine, newspaper, radio and TV company. These sort of 'meet and greets' had been very much the daily fare of the 60s – booze was laid on by the record company, and the group were sure to get their share. Sid's drink of choice that day was vodka. He would make his way through a number of bottles that day.

A very drunken bunch of Pistols – with Sid and Paul Cook now engaged in a fist fight – then turned up at Wessex studios, where producer, Chris Thomas, was finishing off the mix of their single. They weren't really needed here and Thomas wanted to get on with the job in hand, so Malcolm put them back in the limo and instructed that they be driven to the A&M offices in New Kings Road, quite close, in fact, to his Sex shop. During the journey, the fighting between Sid and Paul Cook continued. Cook got a black eye for his troubles, while Sid lost a shoe and cut his foot open in the process. On arrival at A&M Sid, who was now in no state to stand up, slumped into the boss's chair and promptly passed out. They had been taken to the office to select a B-side for the single, but it was obvious from the state they arrived in that nothing was going to get done that day in the line of business. Sid was woken by a glass of wine in the face from either Paul Cook or John Rotten, no-one present seems to remember. Sid raised himself from the chair and went upstairs to the promotions room. There he began to charm the PR girls with his famous "My foot's bleeding, can you find a fucking plaster

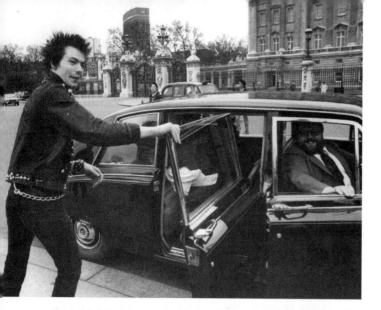

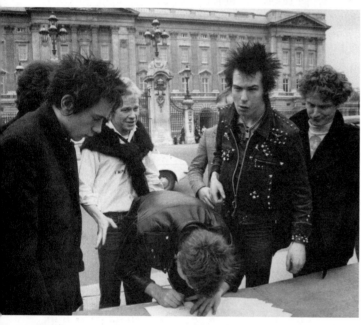

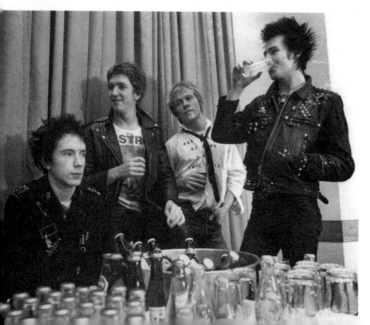

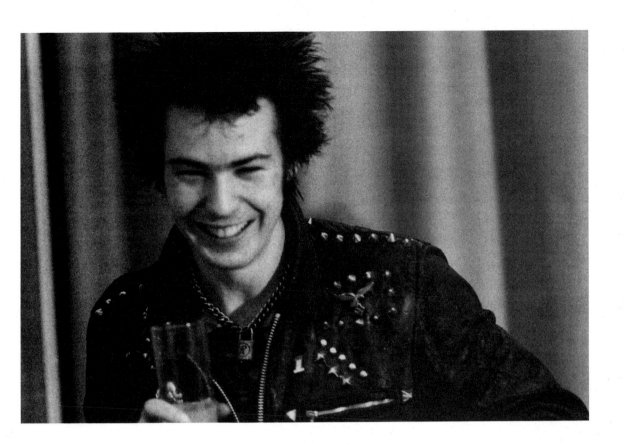

for me, you bitch!" This approach went down like the Titanic. Flummoxed, Sid then tried to wash his foot in a toilet bowl, subsequently broke the bowl, stepped backwards and put his elbow through a toilet window. He was later spotted washing his foot in another bowl.

Derek Green was, by now, in no mood to do any more than get this lot out of the front door ASAP, so he had them rounded up and called down to his office, where he hurried through a tape of potential B-sides before the group, who by now could not care less, chose 'No Feelings' for the song in question and were swiftly shown the front door. The limo driver refused to take them anywhere and told McLaren in no uncertain terms that he would be billed for damage, so A&M laid on a pair of cabs. Back at Denmark Street, Sid pronounced to a TV crew that "I've had the greatest time of my life. This is my first day and as far as I'm concerned it's great being in the Sex Pistols." He ended this momentous day slipping backwards onto Steve's bed and going out like the proverbial light.

Anne Beverley: "It wasn't management of any kind, it was mismanagement. Why would anyone with any sense of what was right put four kids in the middle of a bucket full of hard spirit, and then wonder why it was that the day turned to chaos? I know the Pistols weren't angels, but surely there is a way to handle everything and McLaren seemed to find the *wrong* way to handle everything."

Chapter 10

Derek Green was privately fuming, but publicly he showed the world another face. He talked of extremes and how the world needed a kick up the ass, how all forms of media were changing, how everything would be different. Putting all his worries – and they were many – on the back burner, he ordered copies of the single 'God Save The Queen' to be pressed up the following Friday. But one more piece of the jigsaw was still to be put in place before the pressing was complete. It was decided that the group would take a trip to that most famous of rock'n'roll hangouts, The Speakeasy. After all, Steve and Paul had been hanging out there for ages, so on the same Friday evening that 'God Save The Queen' went to press, the group – along with Wobble and assorted mates – went to the club. Also in attendance that night was 'Old Grey Whistle Test' presenter, Bob Harris. He was having a drink with a group called Bandit. Wobble asked Harris in a very threatening manner why the Pistols had never been on the show and Harris, who really didn't want the hassle, told him it was because they didn't want the Pistols on their show.

From this point on, the blue touch paper had been well and truly lit. It all culminated in a frenzied scene, kicked off by one of Bandit punching Sid because he had told Bob Harris he was 'an old cunt'. One of Rotten's mates told the group – and Harris – that he was going to kill them all. McLaren was greeted first thing on the Monday morning with a letter from Harris's lawyer. It turned out that the management team who looked after Harris included Dee Anthony, who also looked after the biggest-selling artist on A&M Records, which at that time was Peter Frampton, whose *Frampton Comes Alive!* had gone platinum several times over and had contributed millions to A&M coffers.

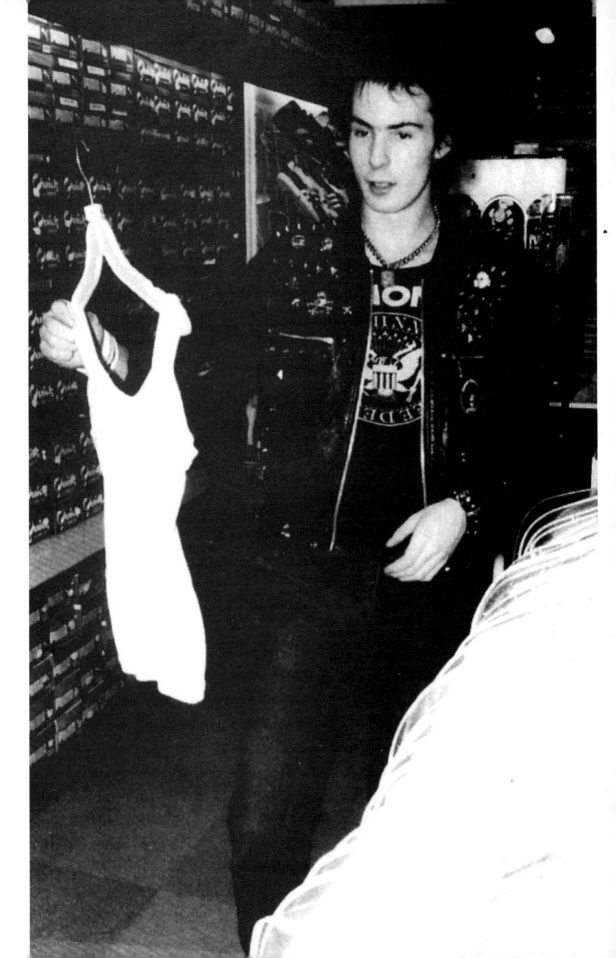

Derek Green, who had obviously received a similar letter, phoned McLaren to tell him these allegations were being taken very seriously; the Sex Pistols had threatened to kill his good friend, and he wasn't having any of it.

Green now finally realised that there were too many problems with this group: ruefully, he would look back on his own actions: he should have met the group before he signed them; he should have hung out with them so he would have known what they were like; he should never have listened to their manager, who was clearly in league with the Devil or, more worryingly, was the Devil himself. As the first batch of 25,000 copies of the single rolled into A&M's distribution point, Green panicked more than ever before. Here was a man who had signed a group that no-one could control, that EMI had fired, against the wishes of his staff. On Tuesday, March 15th 1977, Derek Green took the day off and drove to Brighton to have a long think about his current situation. He had, unwittingly, put his job on the line. From Brighton he telephoned Jerry Moss. He stated that while he no longer wished to work with the Sex Pistols, he didn't think the label should drop them. Given a choice between losing the group, who Moss had never met but was fast hearing bad reports about, and Derek Green, whose opinion he trusted totally, he told Green to terminate their contract on the spot.

Later the next day, Green called McLaren and informed him that the group were no longer the problem of A&M Records – their contract was to be terminated and any pressed copies of their single (a full 25,000, remember) would be junked. He actually went one step further and told his pressing plant to destroy the metal mastering plate for the single. Of course, not all the A&M pressings of 'God Save The Queen' were destroyed; it is estimated in record collecting circles that somewhere between 50 and 500 copies did survive and these now change hands in the hallowed halls of Christie's and Sotheby's for upwards of three thousand pounds each, making it one of the rarest records ever pressed in the history of rare records. Ironically, even The Beatles don't have a three thousand pound single in their catalogue...

The group were presented with a cheque for seventy five thousand pounds, not bad money in any language for seven days of little or no work. But by now, of course, there was no time for celebration. The big joke about the Sex Pistols getting thrown off record labels was wearing thin and, besides, the Queen's Silver Jubilee was fast

approaching – but the group with the new national anthem in their back pocket didn't have a recording deal to issue the single. With nowhere left to turn, McLaren went back to the Notre Dame Church Hall, just off Leicester Square, and booked an almost secret gig: the event would be played to an invited audience of friends and hangers-on. That night, the Pistols were able to complete their first gig with Sid in the line-up and, to be fair, Sid – according to all those present – really did shine that evening. He developed the sneer, pushed his luck a bit and went for it. The gig was filmed by a Dutch TV channel. Upon leaving the hall, Nancy and her rock star boyfriend heard a shout from the crowd outside; "You've sold out," came the cry. Sid was quick to investigate and deliver a punch to whoever had said this – until he learned that it was a pair of East End hard nuts, known to the band. Sid walked away. There was, after all, a real difference between serious hard boys and those manipulated by image and PR.

Anne Beverley: "I went along to the Notre Dame gig, largely because I wanted to be there for his big night, his first night. It was a great show full of atmosphere with John and Sid playing at band leaders. Vivienne, who I didn't care much for at all, was hopping about like Alice in some mad Wonderland of her own making; Malcolm, wanting to be in control and realising it was beyond him and, finally, Boogie who I really liked – a nice guy who looked after Sid."

I remember Anne first mentioning Boogie to me. I thought she was talking about a pet or a piece of kit that Sid had left around the house. No, Boogie was John Tiberi – one of the nicest people I ever met from the Pistols' inner circle. He was an old friend of Malcolm and took over as road manager when Nils Stevenson left the camp to manage Siouxsie and The Banshees. Over the months that would follow, he would be a good friend to Sid – and there was always, sadly, a shortage of those.

The day after the gig, Malcolm sent Boogie and the group to Jersey in order to keep them out of trouble and, more importantly, out of the way while he tried to get on with business. But even the Channel Islands had heard about the Sex Pistols and so they weren't allowed in without a police escort. And even with an escort the group were treated badly, so Jamie Reid (the artist who did all the sleeves for the Pistols) decided they should return to London. Everything was out of control and McLaren, for his part, knew how to wind a situation up, but not how to control one. Boogie decided they

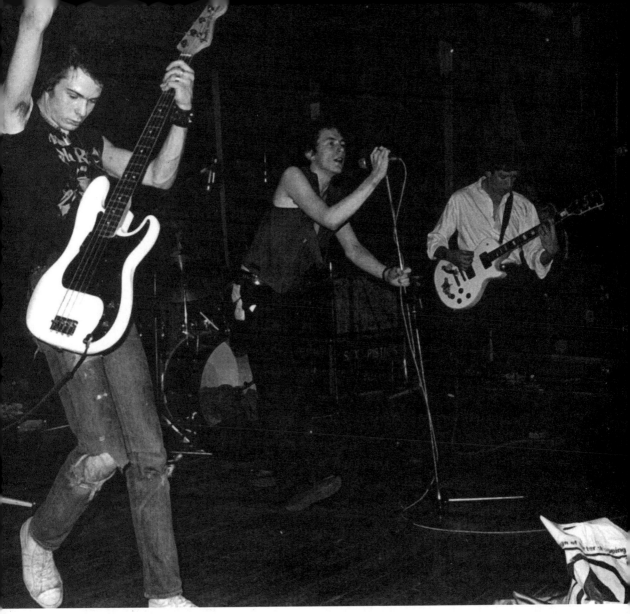

Sid's first gig

should only stay in London for one night and the next day he whisked them off to
Berlin on a sightseeing holiday; he took them to the Berlin Wall, drove them around in
a hired VW and watched on as they wrote the last two original songs they would ever
manage to produce as a group – 'Holidays In The Sun' and 'Bodies'. Most of the group
had wanted to cross the Berlin Wall, but Sid forgot his passport and so they had to
remain on the West side of it.

Nancy Spungen, at the Notre Dame Hall gig

While the group was away and making problems for someone else, McLaren went back to the drawing board. He tried Decca, Pye, Polydor and even EMI again. Larry Parnes, a 60s impresario, had even offered to set up a label just for the group – but if the plan that was now unfolding in the manager's head was going to amount to any sort of a movie, he had to sign another major deal with another major advance. In further desperation, he went back to CBS, but they must have been tipped off that he was doing the rounds because they turned round and offered him a deal that even by the standards of the Sex Pistols story was bizarre: at best, yes, they would have the group, but first of all they weren't willing to pay an advance because, so far as they could see, this group must have banked enough money from what they had made out of EMI and A&M. No, they didn't want the group in their offices, but would be willing to meet them in Soho Square and, finally, McLaren would have to keep them under full control. Not much of an offer, then. McLaren decided it wasn't on. Let's face it: whatever reservations he may have had over some clauses, a document legally binding him *to keep them under control*? Ha! Now there was a hoot.

In sheer panic, he booked another gig. They were, after all, according to his story now banned from everywhere. This wasn't far from the truth, but he could still manage to squeeze the odd one in, just to keep the band in the music press and help them get a

VICIOUS TOO FAST TO LIVE

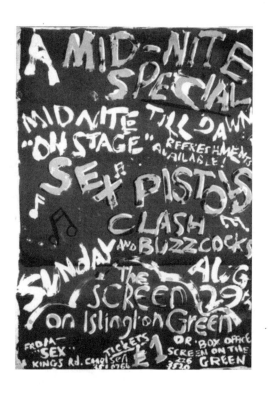

deal. He booked a show at Screen On The Green in Islington on April 3rd 1977. It was a free entry gig, set to begin at midnight, and yet getting in was damned near impossible. This was all done to keep the (then) GLC happy. But this pulled-together-at-the-last-minute event failed to have the desired effect. The following day, five record companies turned the group down. A rather green/grey looking version of Sid – who only left the house these days to be a Sex Pistol – was admitted to hospital with hepatitis B. He had done the Screen On The Green gig very stoned, then left quite quickly to score more heroin with Keith Levine. It was decided by McLaren, who really didn't need this on top of looking for a recording deal, that Sid and Nancy had spent enough time living on the floor at Linda Ashby's flat; they should be returned to Anne Beverley. But Anne had a new boyfriend, Charlie, and the odd couple weren't welcome at this point. Nancy ended up staying at Linda's and Sid was placed in the care of Al Goldstein, a friend of McLaren's, for a few days.

Nancy, Sid and Lemmy at the Speakeasy

Chapter 11

"I WAS GIVEN THE OPTION OF TAKING ON SID AND NANCY. I'LL BE HONEST WITH YOU; THE FIRST TIME I SAID, 'NO, FORGET IT'. YOU KNOW, YOU LET IT GET TO THIS STAGE AND THEN YOU PASS THEM ONTO ME? NO, NOT INTERESTED. BUT LIKE ALL THINGS THAT WOULD HAPPEN, EVENTUALLY YOU THINK, WHO ELSE IF NOT ME?"

(ANNE BEVERLEY)

Sid spent a month in hospital and they did a fairly good job of cleaning him up; while this was going on, Richard Branson, who had been in the game from almost day one, who had tried to buy the group from EMI in a deal that never quite came together, had made another offer and signed the group to his Virgin Records label. Right from the start, McLaren had assurances that nothing would put him off; he was in for the long term. Mavericks like Branson and McLaren were surely made for each other? At this point, McLaren could see there would be no more big record deals, so he passed the day-to-day running of the group over to Boogie and his assistant, Sophie. He stepped out of their lives and concentrated on the movie – his movie, his vision – *Who Killed Bambi?*.

All the insiders, from the group to their management team, pretty much ignored Sid while he was in hospital. His so-called friends didn't visit, but Nancy did. She saw this as her clear chance to bond with Sid like never before. From his release from hospital on May 13th onwards, Sid and Nancy may well have been joined at the hip.

The contract signing with Virgin took place on May 12th, excepting Sid, who signed

(finally) on May 16th. While he had been in hospital, the three other Pistols had finished recording and mixing their debut album. All seemed well on the surface, although Sid and John were sliding further apart. Despite all this, Virgin announced a release date for the 'God Save The Queen' single of May 27th – in the hope that they could get it into the charts by the following week which would be, after all, Jubilee week.

Putting this record out was never going to be easy. Bad enough was the fact that A&M had not only pressed copies already, there had also been a certain amount of radio play: this meant that the whole shock tactic strategy favoured by McLaren and Virgin was virtually torpedoed. The Jubilee celebrations were in full swing and the Pistols were to be the ultimate party-poopers. But had their thunder already been stolen? On May 17th, after a new metal pressing plate had been made for the single, workers at CBS, the pressing plant that was making the finished product – complete with a new B-side 'Did You No Wrong' – walked out in protest after hearing the song. Richard Branson decided that if this was going to be the case, he would press the single himself as a double thickness flexi disc, thus cutting out the need for a pressing plant. Upon hearing this news CBS, who thought they might lose the entire Virgin contract altogether, went back to their factory and continued making singles. Carri on Sex Pistols, indeed!

It was a joint decision between the Sex Pistols management and Virgin that the single would have a massive advertising campaign. Boogie and director Julien Temple arranged to shoot a promo video at The Marquee Club on Wardour Street in London. The promo clip was put together on the afternoon of June 23rd. Sid was still very ill and John was playing at being a pop star and wanted everything to be done for him. But Steve and Paul saw their chance and managed to pull something real out of the chaos: the result was a great little video for the single. On top of this, Virgin gave Jamie Reid a five thousand pound budget to cover advertising materials: for this, he produced 1,000 double-crown posters, 3,000 quad posters, 6,000 stickers, 3,000 streamers, transfers, T-shirts and a whole stack of media advertising. This would largely all end up in auction houses years later because upon the release of the single on June 27th, the record was given a blanket ban by all media: Woolworths, Boots and W.H.Smiths all refused to stock it. Slight conflict of interests there: they were, of

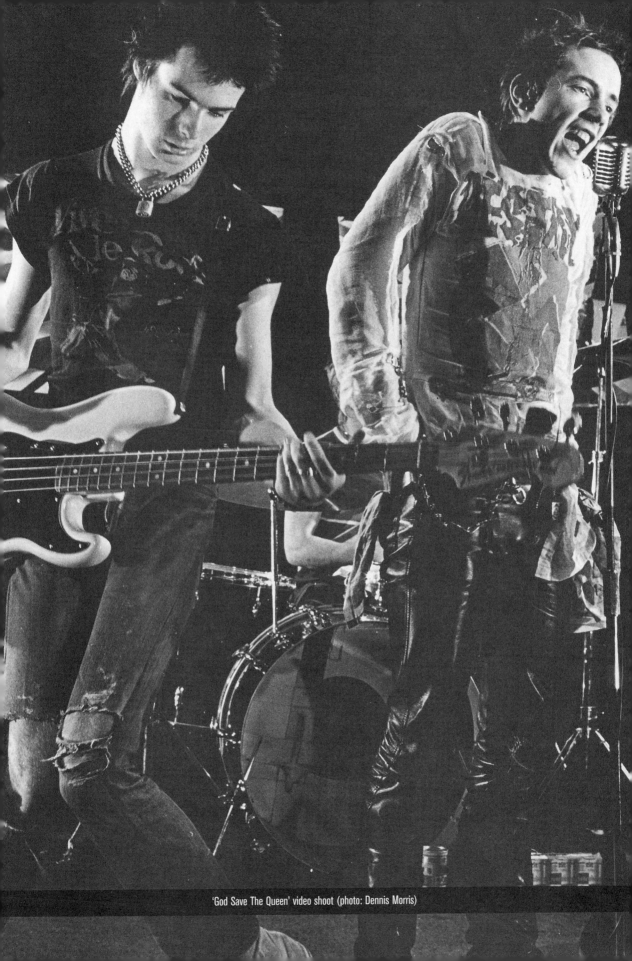

'God Save The Queen' video shoot (photo: Dennis Morris)

course, all involved in selling official Jubilee merchandise.

The UK music press, however, took the group's side, giving them the cover of *Record Mirror* and *Melody Maker* as well as the legendary *NME* overkill issue – which saw them pop up in just about every section of the magazine. Almost all this PR work was done by John and Steve because Sid was busy feeling terrible and succumbing ever deeper to the twin grip of Nancy and heroin. Remarkably, despite this countrywide ban, the record sold 150,000 units in five days. This made it a Number One single before the charts were even printed, though the only DJ playing it with any clout at all was John Peel. Above all else, the Sex Pistols, via a banned single that charted instantly at Number One, became the punk movement's *de facto* leaders: they took up so much space in the national and musical press, at the time there was barely room for anyone else.

Anne Beverley: "Before the record even came out they had been called public enemy number one, but now it was real: the group who had caused so much trouble for the establishment was now at the head of the pack and that was incredible news for them. But Sid was very quiet at that time, only later did he say to me that he didn't 'mind being at the centre of things', but it all felt very strange. When he had sat at home day-dreaming about Bowie and Bolan, he hadn't realised just how much of their lives was boredom and sitting around. When 'God Save The Queen' hit the charts, he finally realised that it wasn't all quite as glittering as it looked on TV."

The group had their own Jubilee boat party. On the evening of June 7th a boat, the aptly named Queen Elizabeth (what else could it have been?) was booked by Virgin. It was soon adorned with a banner, 'Queen Elizabeth Welcomes The Sex Pistols', down one side of it. All the in-crowd were present, the punk elite, music press and TV, along with another bunch of suckers who were invited and left standing at pier head. Nancy was along for the ride with Sid and Linda Ashby, a rare event in that Malcolm had managed so far to keep the woman, who Rotten hated, at arm's length during almost all official functions. Anne Beverley was onboard too. She had this to say about the event: "We had to be at the pier for 7.30pm and they cast off not long after; many people got left behind, but I got the feeling that bit was planned. Malcolm wanted to show who was in charge. Richard Branson offered me a drink and asked about Sid.

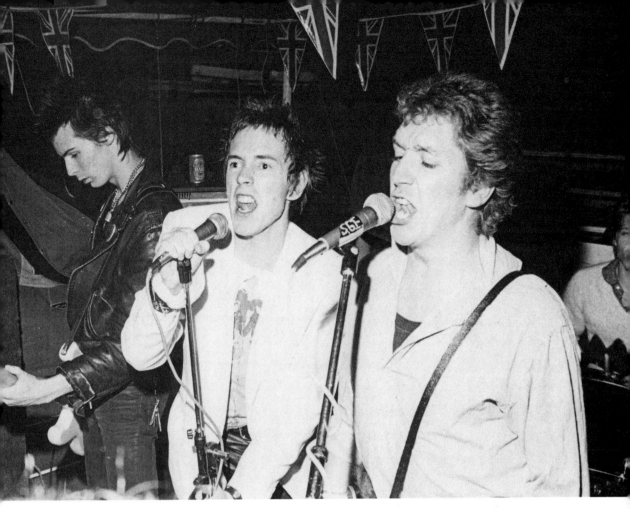

The Jubilee boat trip (photo: Dennis Morris)

The whole evening was the usual faces; for that one night only Nancy – who was clearly under the impression that the nicer she was to me the more chance she had of borrowing some money – told all her friends I was mom. The group played later in the evening although the stage was very tiny and they didn't get too far into their set before the power was turned off and the police arrived. Our boat was pulled to the side and several arrests were made. I don't know what anyone thought they were going to achieve beyond what did happen: the whole idea had chaos written all over it."

Boogie managed to get the group out of the way, while various arrests were being made, including Malcolm, Vivienne, Jamie and a host of Glitterbest staff. Those arrested spent the night at Bow Street police station. Jamie Reid had been badly

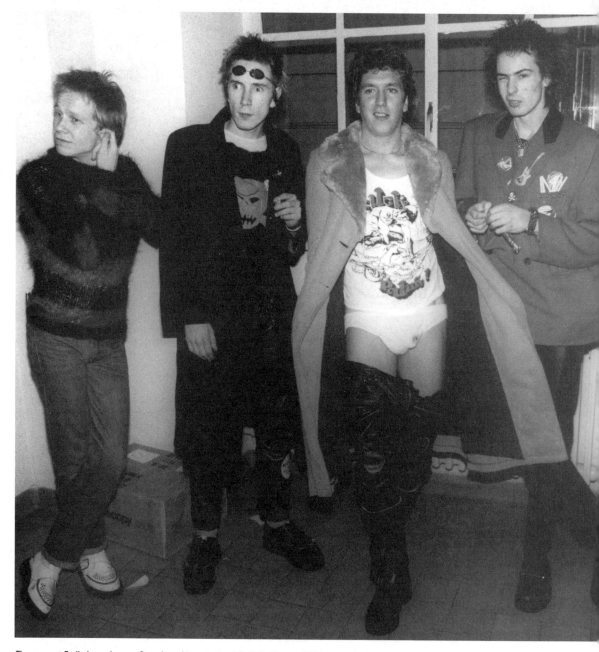

The group at Radio Luxembourg – Steve loses his pants (again!). Sid's Westwood/McLaren jacket was later swapped with Steve for his leather one (photo: Bob Gruen)

kicked and beaten in the police van, as had Vivienne. If the event did anything at all for the single it was in shifting another 50,000 copies that week, making the total for Jubilee week around 200,000. By chart day the group were outselling all competition by at least two to one, but the BMRB (British Market Research Board) decided it was

having none of it and the Number One single for the week was announced as 'I Don't Want To Talk About It' by Rod Stewart. Malcolm, who had realised that both singles were distributed by CBS, checked with the company: they told him the figures were right – the Sex Pistols had totally outsold Rod Stewart, but their faces didn't fit and for the first time in rock n' roll history a single that was indeed Number One was placed at Number Two in all charts. The Establishment really had closed ranks, just as it had always threatened to do. 'Top of The Pops' – then the nation's prime pop show – bottled it. In TOTP land, Rod was king!

The following week, the backlash proper started. Jamie Reid was attacked by persons unknown and received a broken nose and leg for his trouble. Paul Cook was attacked by Teddy Boys on Goldhawk Road and hit across the head with an iron bar and John Rotten was attacked by knife-wielding thugs while leaving the recording studio with producer, Chris Thomas. And all this because of a 7-inch black vinyl single...

Chapter 12

Sid and Nancy were living in Chelsea Cloisters at the time. "A smaller flat you have never seen, we used to joke that you had to stand in the shower to fry the bacon," says Anne Beverley. "But having said all that they liked it, at least up until Jubilee time when all the trouble started; then it became more like a prison. They could barely ever leave the place. Of course, this meant a deep descent into heroin addiction because – beyond sex – that was all Nancy ever did. That was her trip and now she was dong it 24/7."

On June 27th, Sid called Sophie at Glitterbest at midnight. She must get them out of the country because everything was getting on top of them and they couldn't deal with it. The next day, John Rotten rang her, singing from the same hymn sheet. McLaren started making arrangements. They would tour Scandinavia straight away. During that week the Pistols camp grew further apart: Sid and John argued even more, Steve and Paul were sick of the pair of them. Although the group wouldn't actually call it a day for another nine months, it was during that week that they fell apart in a way that the court of King McLaren would never be able to fix again.

Beyond all this, the group hadn't toured – or indeed looked like touring – the UK in an age, certainly since Sid had joined the group. A decision was made to put together a tour just before Christmas, regardless of council bans around the country. The group would go out and play under various names, including The Tax Exiles – although the tour would always be known by fans around the world as the S.P.O.T.S tour, which stood for Sex Pistols On Tour Secretly.

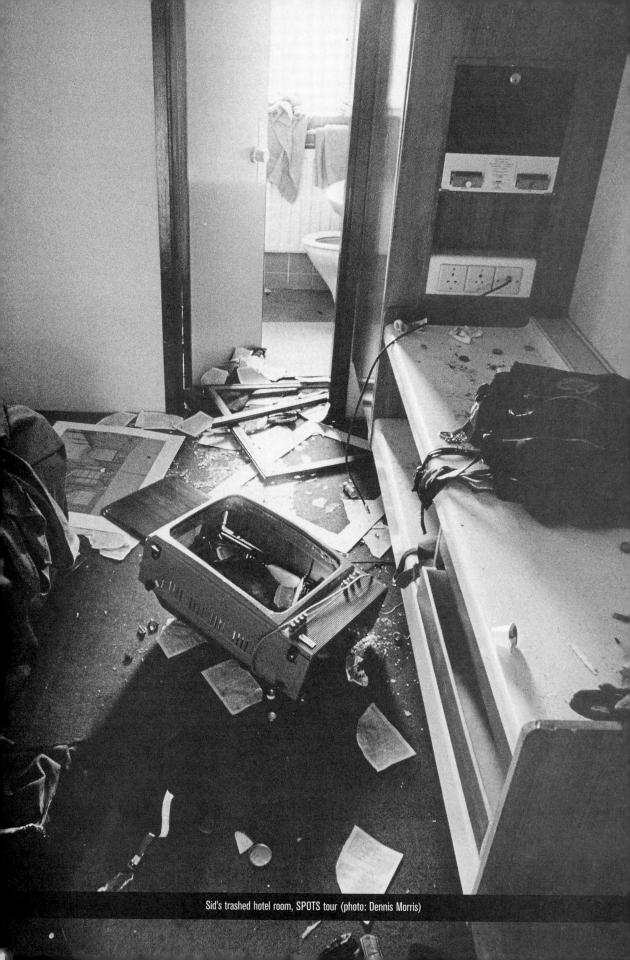

Sid's trashed hotel room, SPOTS tour (photo: Dennis Morris)

Before this, and post-'God Save The Queen', the group issued two more singles: first, 'Pretty Vacant', which did get them on 'Top Of The Pops' although in this case against their wishes and, later, 'Holidays In The Sun', one of only three songs the group would complete after Glen Matlock had left. Their album *Never Mind The Bollocks Here's The Sex Pistols* (originally titled 'God Save The Sex Pistols') had made it to Number One without getting replaced by anything and in spite of a blanket ban by chart return shops like Woolworths, Boots and W.H.Smiths.

Over the years Sid's involvement with the album has been the subject of much speculation. First of all, is he on it? The answer to which is, yes: he plays some bass on 'God Save The Queen' and 'Bodies', although both are mixed very low and later overdubbed by Steve Jones. While at Wessex Studios for the recording of the album, Sid was spotted on the roof one day cycling around the edge. When told if he fell off he would kill himself, Sid replied: "Is that all?" and went back to his cycling. Not entirely surprising that his contribution to the album was as minimal.

In his UK hotel suite, the day after the film premiere of *The Filth And The Fury*, I asked Steve Jones if it bothered him that all these years later Sid still sells T-shirts on a level that the rest of them could only dream of. Steve told me they always knew it would be that way because Sid was the face – not only of the group, but of the whole movement.

Scandinavia had certainly given Sid the chance to be one of the group. For the first time, he had fitted in. Although his one riff – learnt that night while bashing along with The Ramones in the background – was all he could muster playing-wise, his personality and his one-liners were putting him onto the same footing as John. In many ways the group now had two front men and their appointed leader was none to pleased about the arrival of any competition. Besides, most of the gigging the group did that summer was more like a mission to push an image, an extended public relations exercise rather than just being about a group out on the road.

The plot hatched between McLaren and The Cowbell Agency – the group's tour bookers – for the SPOTS was perfect. Already banned by more than enough city or town councils, the idea was simple enough: announce a gig the day before and play

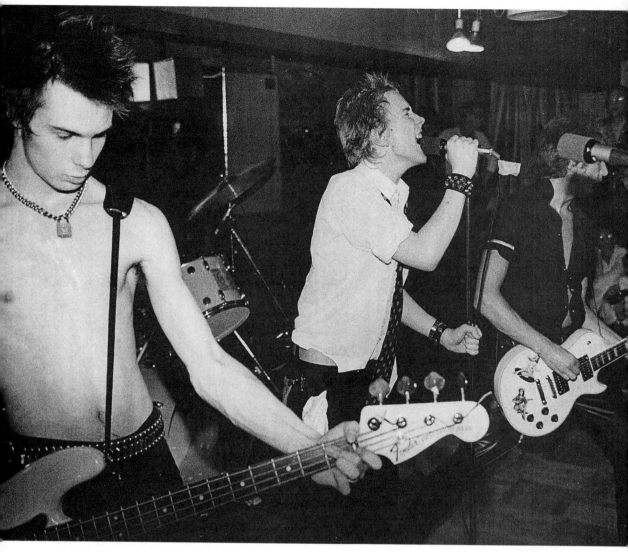

Live in Sweden (photo: Dennis Morris)

the following day under another name; if anybody sussed them, simply pull the gig and move on to the next town. Which is exactly what happened in my hometown of Blackburn in Lancashire. Announced at King Georges Hall under the name 'Special Guests', tickets went on sale one morning and flew out of the door. The venue (which is council-owned) couldn't understand why a group they had never heard of was selling tickets so fast. A decision was made to check out who 'Special Guests' were: the following morning, safe in the knowledge that this was indeed the Sex Pistols, the gig was cancelled and all tickets refunded. In some places, however, things went a lot smoother, Doncaster, Scarborough, and Middlesborough all managed to pull off

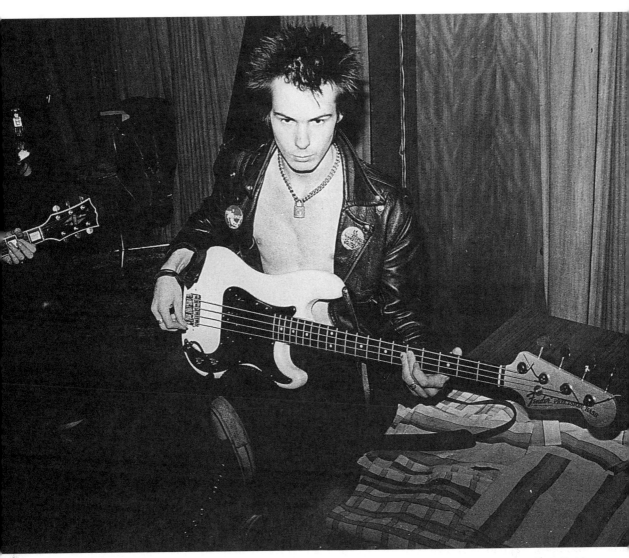

Backstage, Sweden (photo: Dennis Morris)

successful gigs without anyone – outside the group and the kids – ever knowing who had been in town that night.

During this tour, everyone involved agreed that Sid changed. Rather than being the young kid racing to catch up with his image, it was as if overnight he had turned completely into that image: all the sex, drugs and rock'n'roll that could be pushed his way he freely consumed. The warped dream of McLaren and Westwood that, maybe, one day Simon Beverley would actually shed his skin and become Sid Vicious, was finally a reality. "I don't think they ever understood that they destroyed him," says

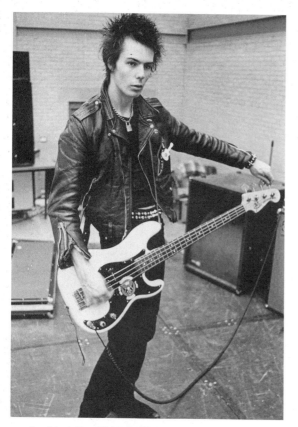

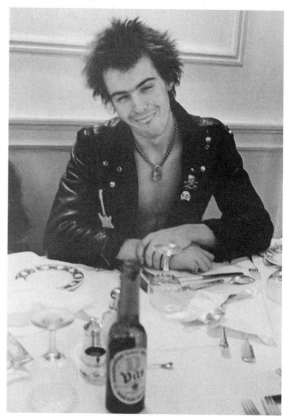

Soundcheck, Brunel University (photo: Dennis Morris) At the hotel, Penzance (photo: Dennis Morris)

Anne Beverley. "They took my son and they moulded him into this icon, very much of their own making. I saw him a couple of times over that Christmas and he had changed. He used to have a cheeky smile and a glint in his eyes, but after the end of 1977, I never saw the smile or the glint again."

At the end of the tour, Barbara Harwood, the band's driver – who had an interest in homoeopathy – was approached by Sid. He asked her to take him away from the whole scene and clean him up, to help him lose the image for him, but he was asking way too much. Barbara, who years later would work with drug addicted teenagers because of Sid, felt like she couldn't offer him what he was looking for; she knew he needed the image to sell the group, but she could also see that he had grown tired of it. If anything, he wanted his life back. But then he also wanted the fame. His situation was a tragic 'Catch-22'.

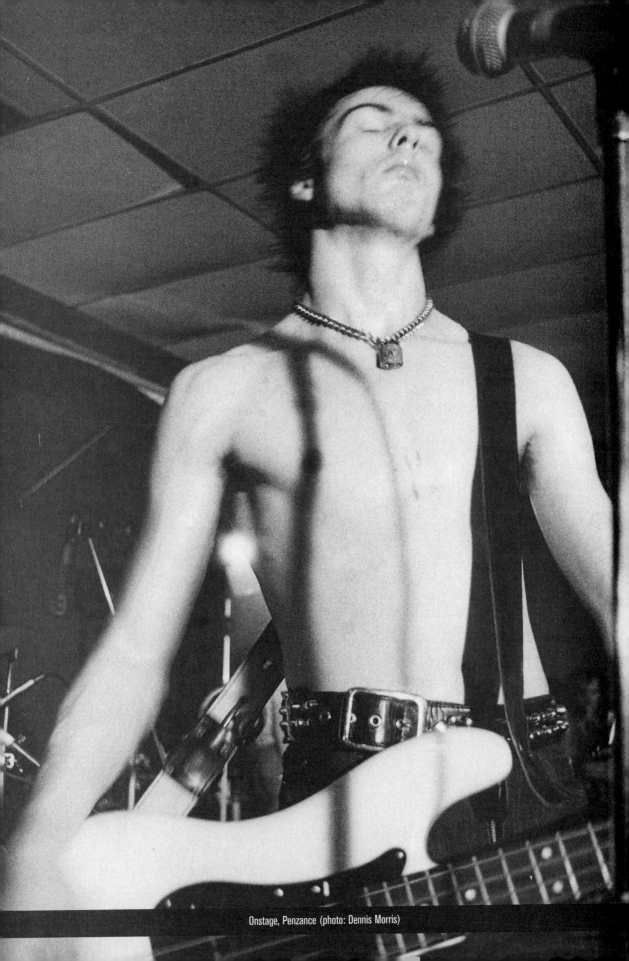

Onstage, Penzance (photo: Dennis Morris)

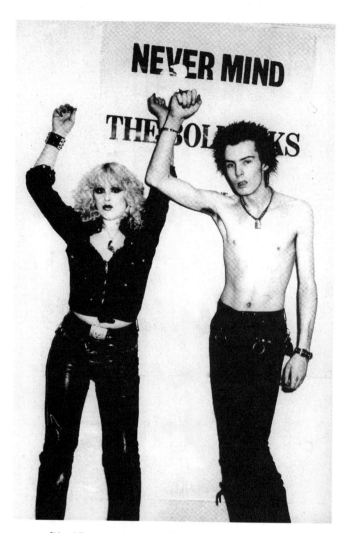

Sid and Nancy: promo session at Anne Beverley's flat

At the end of the tour, during a gig in Penzance, Sid broke down like never before. After the show, he went straight back to his hotel room and hid himself away. The image could only be pushed so far and certainly on that tour it had reached breaking point. It was at this hotel that Jah Wobble turned up. John Rotten was much closer to him than anyone else. Far from being a high point in the Pistols' career, it would mark the beginning of a new chapter – but not quite yet...

Chapter 13

At the end of November a decision was made by the Glitterbest team that, if Sid was going to survive, the only way forward was without Nancy. Over the months, Sid had become closer and closer to this crazed American chick. But because the group as a working unit was almost completely inactive, Sid was left with filling in his rock star score sheet and doing what he thought rock stars did: so he smashed up a hotel room because Keith Moon had; he got deeper into heroin because Keith Richards had; he hung out at London clubs – not sure why he was there because he didn't know if the group he belonged to existed from one day to the next. But all the time Nancy, who had dreamed of this position since childhood, continued to push the buttons on the walking, talking Sid Vicious doll.

A plan was hatched that Nancy would be kidnapped and put onto a plane at Heathrow Airport, while Sid was sat in a dentist's chair paid for by Malcolm with the dentist under instruction just to keep him there. But the plan never got any further than the West End: Sophie and Nancy were to be found arguing in the street, while Malcolm and Boogie ran around like headless chickens trying to dream up a plan 'B'.

"I'm sure they thought their idea was perfect," says Anne Beverley. "But, in truth, it achieved only two things. Firstly, it made the bond between Sid and Nancy watertight and, secondly, Sid's resentment at Malcolm grew so intense that day that he never shook it off. He began to think the man was a fool, a wicked, self-centred manipulator, who hated everyone."

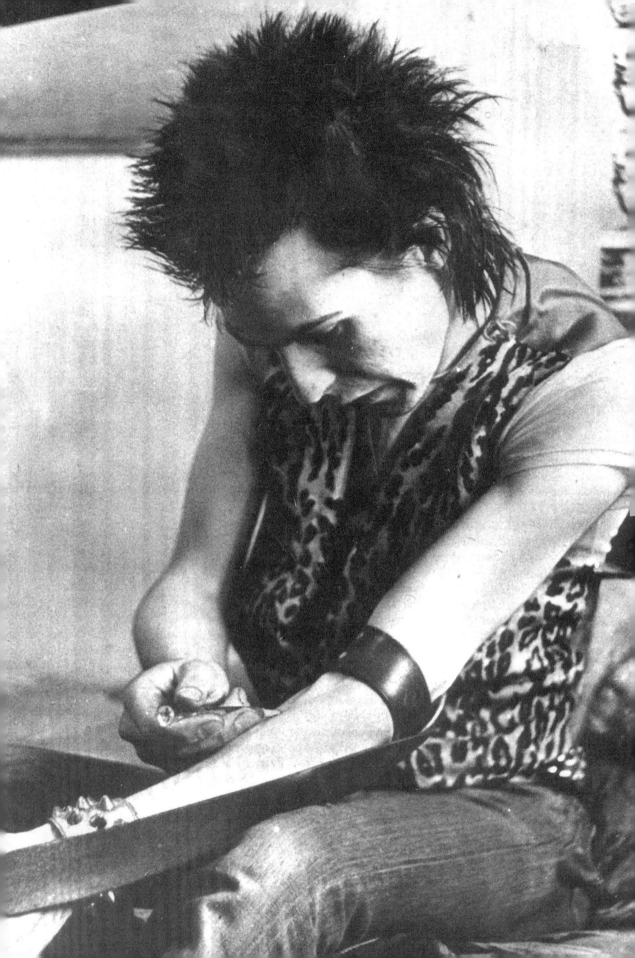

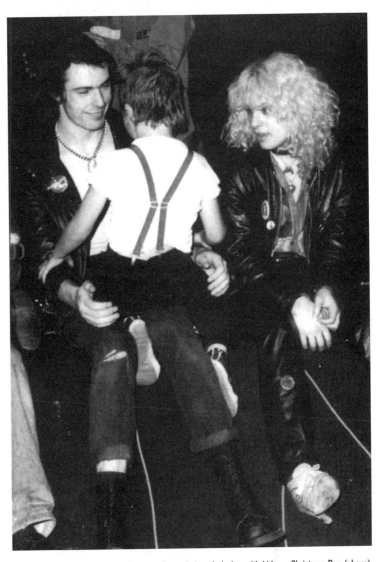

Two sides of Sid – fixing up (opposite) and playing with kids on Christmas Day (above)

The group were packed off to play in Holland on December 5th with Boogie in charge. But the four guys Boogie took to Holland were no longer a group. Steve and Paul had pulled together and in doing so pushed the other two out. John was so convinced that his manager was the enemy that he was wiling to cut him no more slack and, beyond this, his personality had changed greatly. He was no longer interested in anything around or about the band. It was his show and no-one else's. Meanwhile, Sid was now operating on automatic pilot, present in body but not in spirit – still convinced the other three just weren't giving it enough.

The last ever Sex Pistols gig in the UK was played on Christmas Day in Huddersfield. Strangely enough, there was no sign of any bans. A poster was produced just for this one show, which stated quite clearly that the Sex Pistols would be playing. It was, despite all you've read so far, a charity gig for the children of striking firemen who, without the group, would not have had any kind of Christmas that year at all. Two shows were played: the first in the afternoon – a kiddies party with food, soft drinks and lots of presents and free gifts. The Pistols loved this atmosphere and they mucked in, gave out sandwiches, started a fight with cream pies and trifle. Sid, along with Nancy – who had been allowed to attend – loved the afternoon show. They dived into everything and had fun with the kids. It was like they had found their own gang. The evening show was a little more business as usual, but the gigs were a high point at a time when the group had had little else to shout about.

During the day, Julien Temple filmed everything, including Sid and Nancy's failed attempt to have sex on a *Never Mind The Bollocks* poster. Sid sang two numbers that night: 'Chinese Rocks' and 'Born To Lose', both of which had been written by The Heartbreakers, the group Nancy had followed to the UK. The two songs proved that, while he was no great shakes as a bass player, Sid the nascent front man was a force to be reckoned with – something John Rotten knew already.

The plan had been that once the Christmas Day gig was over, the group would get four days off before flying to the USA. McLaren had decided that the US was the next logical step. Rumours of a Boxing Day gig in London, possibly at The Roxy, in the end came to nothing. But with America there were already problems: in an attempt to push the seedier side of the group and gain a few early headlines, McLaren had filled out all their entry visas remembering every brush with the law any of them had ever had and – in Steve Jones's case – that hit double figures. So it was no surprise when their request for entry visas to do the tour was denied. After many phone calls to and from America, most importantly to Rory Johnson, Malcolm's man in the USA, the visas were finally organised and the band arrived in New York on January 3rd 1978.

But they wouldn't be playing in New York or L.A., or indeed anywhere that you might expect to catch a group that was trying to break America. Instead, this tour would concentrate on the Deep South, playing largely to small clubs of punters, on a similar

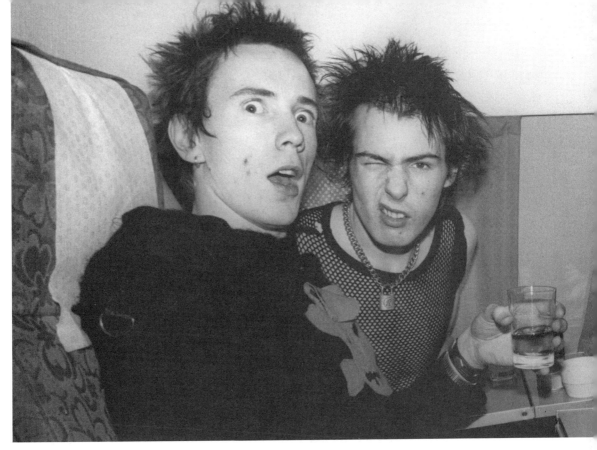

Lydon and Beverley – a friendship which would soon be over (photos: Bob Gruen)

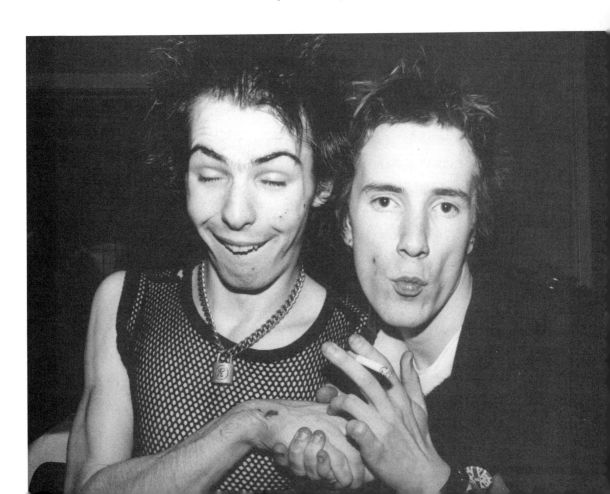

level to everything they had done already in the UK and Europe. The only exception was to be the last show on the tour: a one-night stand at The Winterland Ballroom, San Francisco; with an estimated capacity of 2,000, it was the biggest show the Pistols had ever played at that point.

Warner Brothers, the group's American record label, had decided it was taking no chances. The group would be looked after by a team of their choosing. They'd seen and heard enough to know that McLaren had nobody on his team who could do the job the way they wanted it done. So while Boogie and Malcolm were in attendance, so were Noel Monk (who would eventually manage Van Halen) and his team of roadies and minders. For the most part, the group would travel across country by Greyhound bus. Nancy, by order of McLaren (although to be fair on him, all three other group members were also pushing for this decision) was not invited on the USA tour. In exchange for what Sid saw as a major compromise, the pair were found a better flat in the Maida Vale area of London, in Pindock Mews.

"Pindock Mews was their only real home," says Anne Beverley. "They made it real, put up their posters, moved in Sid's juxebox and motorbike. It is in a wonderful area. I had high hopes when they moved in there, but most of my high hopes were based on the pair of them cleaning up. I didn't realise till years later that by the time they arrived there, any chance of that happening was long gone. They had set themselves on a one-way course and nothing anybody could say or do was about to change that."

On January 5th, the group comprising four people who didn't really get on any more, a tour manager with no concept of this kind of tour, the hired-in Warners people and a bus driver, flew to Atlanta, Georgia, where the next act in this rock 'n' roll pantomime would take place.

Their first gig was nothing special. They were supposed to impress so, true to form, they didn't. Sid went off straight afterwards with some fans. Nobody had a clue where he was, but the next morning he just turned up at the hotel. This was to be his first encounter with Helen Killer, an American superfan, who would turn up right through the tour. Above all else, she was obsessed with Sid which, like most things in his life at that point, didn't mount to a particularly good thing.

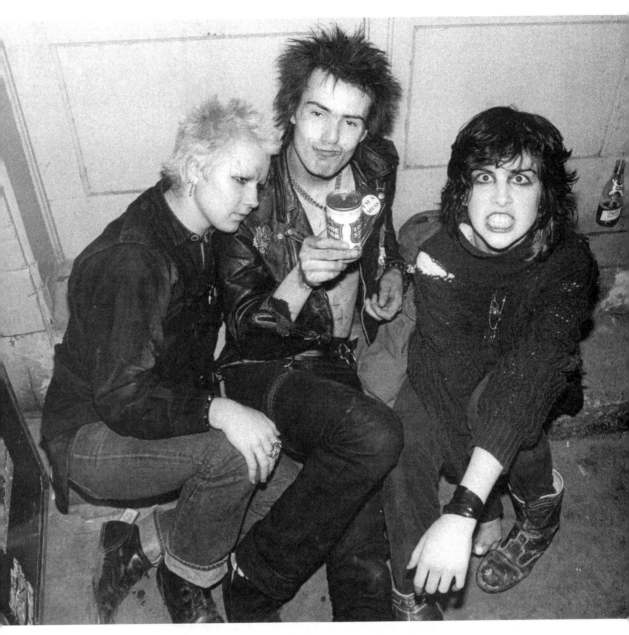

Backstage with female punk fans – including Helen Killer (left), who followed Sid across the USA (photo: Bob Gruen)

Sid was in the middle of a country he didn't know, cut off from his heroin dealer and doing cold turkey in the worst possible place, on the road. This would result in many cases of going AWOL, promote a tendency to latch onto anyone with money or drugs or both and, in one extreme case, prompt him to take a razor blade to himself and gouge the words 'Gimme A Fix' into his chest. So the Sid that found himself on tour in

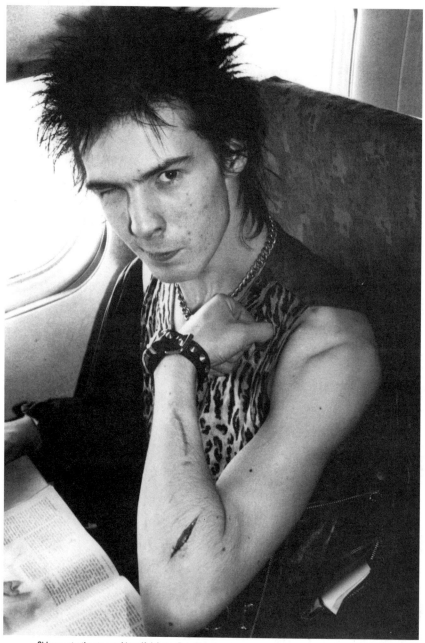
Sid was starting to cut himself (photo: Bob Gruen)

the Deep South was cutting himself up – because the real physical pain beat the pain of being deprived of drugs. The American crew found the only way to deal with him was to baby him, so often they would bath him and talk to him till he got tired enough to sleep. None of this was helped by the fact that a film crew were following the group around the country with no-one's permission, filming everything they could. The results would emerge later in the sickly-titled documentary *D.O.A.*

Chapter 14

"WE' RE BETTER THAN ANYONE, AIN' T WE? EXCEPT FOR THE EAGLES. THE EAGLES ARE BETTER THAN US." (Sid Vicious)

By the time the tour hit the half way stage, Steve and Paul decided that rather than travelling everywhere by bus, which inevitably involved some amazingly long journeys, they would take to the air and travel by plane, leaving John Rotten on a bus in the desert with the hangers-on, record company mob and, of course, Sid who, for his part, was now trying to suppress the pain with two bottles of peppermint schnapps a day. It was during the next few days that three of the great Sid tour stories took place.

First of all, he decided photographer Bob Gruen's motorbike boots were the best thing he'd ever seen, so he had to have them. During the night on the bus, while Gruen was asleep, Sid put a knife to his throat. But before he went any further, Bob Gruen woke up. A deal was done and the boots now belonged to Sid. Next up: in a roadside diner one day, Sid was eating ham and eggs, while also being picked upon by a cowboy because of his appearance. In order to prove who was toughest, Sid took out his pocket knife, carved into his hand, let the blood run freely into his ham and eggs and just carried on eating, after dropping the immortal line: "All cowboys are faggots." The cowboy left, unwilling to go head to head with Sid. The final story in this triad of woe went like this. One evening after a gig, Sid was confronted by a couple who informed him that the woman wanted to have sex with Sid. "Give her something to remember you by," the husband told Sid. Which is exactly what our hero did; he took the woman to his hotel room and without further ado he dropped his trousers and emptied his

Sid in the diner (photo: Bob Gruen) and (below) with Bob's boots (my favourite Sid photo – Anne Beverley gave me the original)

bowels all over her chest. He crapped on her, basically.

When discussing this story years later in a Maida Vale pub with my mate, Mick O'Shea, we came to the conclusion that wherever she is now, that lady can be sure to have taken something away from that tour to remember Sid by: so if that's all that was supposed to have been achieved then... job done.

On January 10th 1978 in Dallas, Texas, Sid went crazy on stage and cut himself open. He allowed blood to run across his chest and face and when the blood started to dry up, he leant into the audience and took a headbutt from a girl. The girl in question was, inevitably, Helen Killer, who would later attempt to give Sid a blow-job mid-gig, while Rotten laughed ever louder and urged the fans to, "take a look at the living circus".

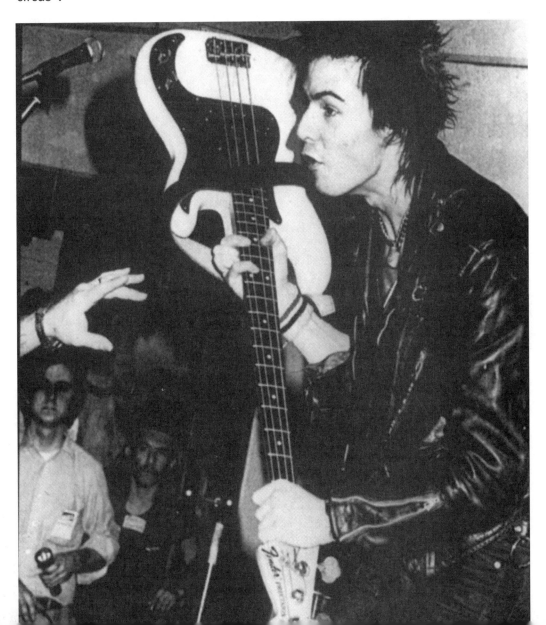

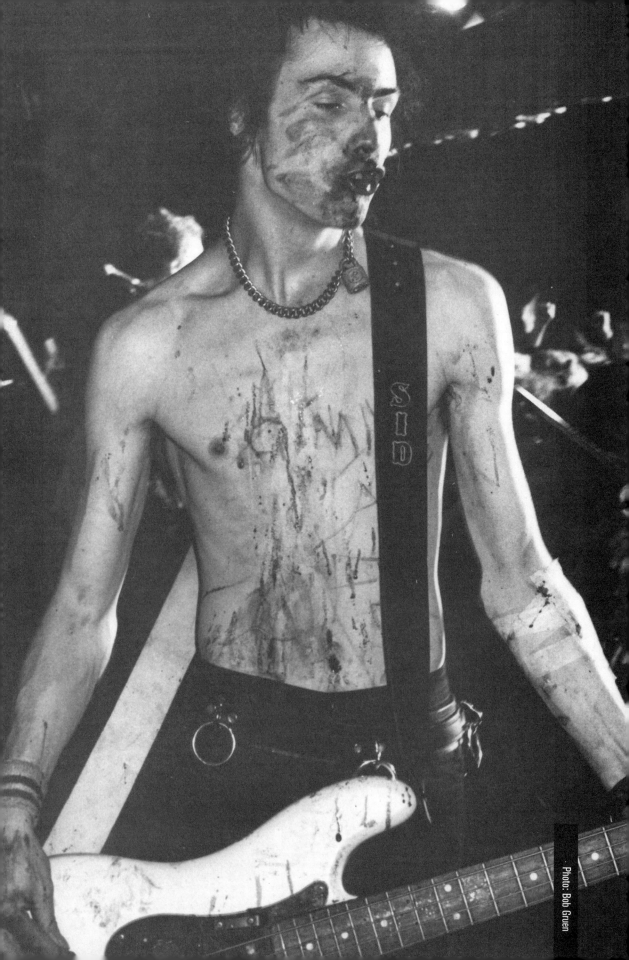

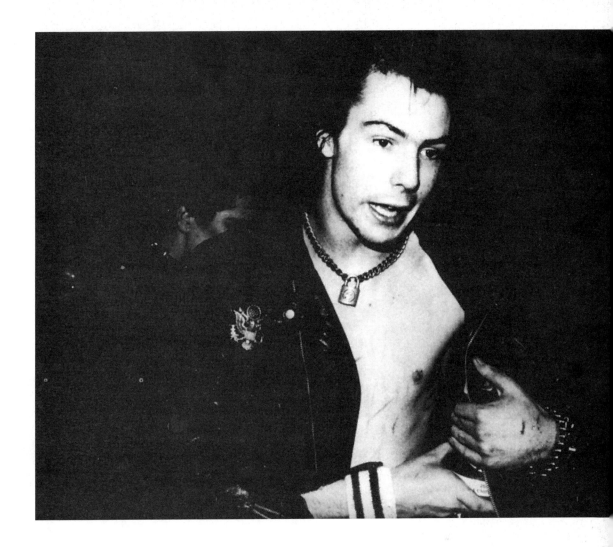

In the early morning of January 14th, both Sid and John arrived in San Francisco. Steve and Paul had arrived the day before. Sid and John, accompanied by minders, went to a sex shop where they were bought various items, including leather jackets on the Warner Brothers payroll. Although the whole Sex Pistols party were booked in at the Miyako Hotel, neither Rotten nor Vicious bothered to check in at all; the pair did an interview with Radio K-San FM (Jones and Cook had done their stint the day before) and Sid slipped away to Haight Ashbury with some punk girls. It was the only day in America that he did any heroin, but it also happened to be in the afternoon before their biggest and most important gig to date.

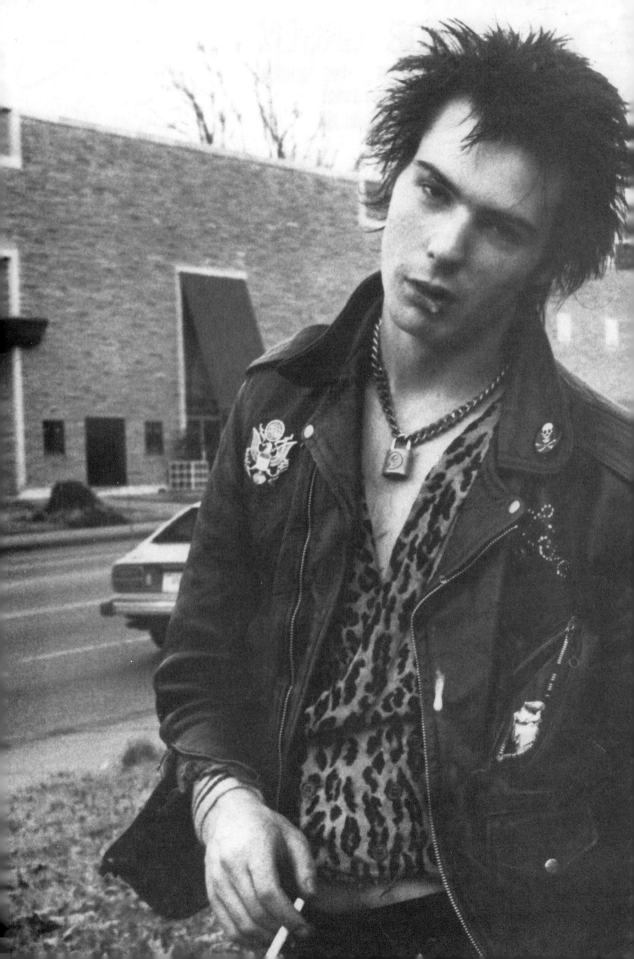

photo: Bob Gruen

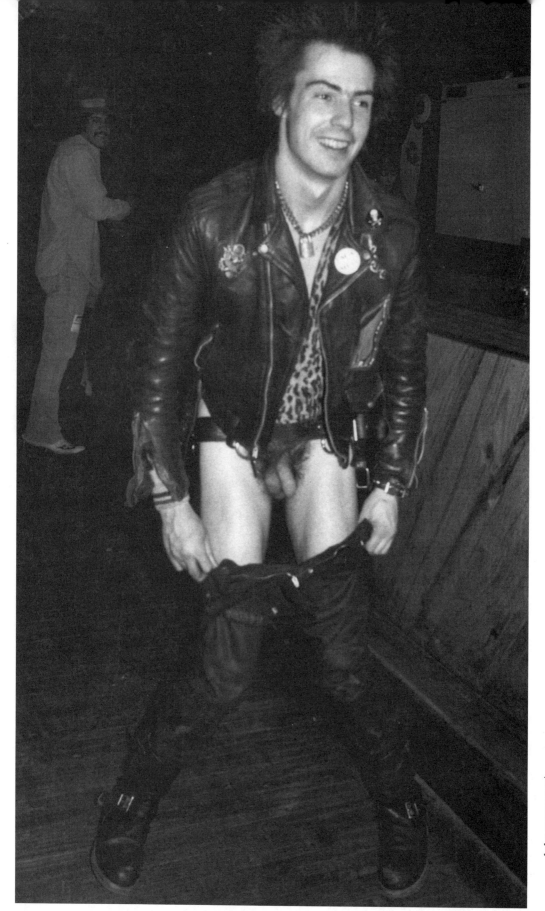

photo: Roberta Bayley

The show at the Winterland Ballroom that night was a nonsense, far from the great rock'n'roll show it was supposed to be. It crumbled into what happens when a joke is wearing so thin that it stops being funny anymore. Steve was ill with flu and a terrible rig meant his guitar kept cutting out. Paul was the only group member able to give the thing a real shot and on his own that didn't count for much. John was much nastier with the audience than ever before, he simply didn't want to be there. Sid was so far out of it, he would have needed a flight ticket to get back. That night the group played one new song. As with some of the other American gigs they ran through 'Belsen Was A Gas' – the very fact that it represented the only new material on the tour indicated where the group were at: the song had been written in 1976 for The Flowers Of Romance, a group that never got past jamming together in somebody's squat. At the end of the show, John Rotten delivered the following line, laughing manically: "Ha, ha, ha. Ever get the feeling you've been cheated?".

The truth was out: although no-one present that night knew it, the Sex Pistols – those four spiky tops from Shepherds Bush – had just breathed their last.

Backstage, the core of San Francisco's elite waited to party with the Sex Pistols. Sid sat among a group of beautiful teenage girls and asked, "Right, who's going to fuck me then?" To the surprise of those present, many volunteered for the job, even if Sid was in no state to perform.

The next stage in the masterplan to conquer the world was to travel to Rio the next day. Not only to do a concert – but to hook up with a genuine bad boy, Great Train Robber, Ronnie Biggs. But before any of this could be put into effect, the whole shooting match went sideways. Rotten had a meeting with McLaren, Jones and Cook, where he informed them it was all over and quit the group. He was helped out by photographer Joe Stevens because nobody would pay for a flight out of America for him. Even Warners, the record company he was signed to, wouldn't take his phone calls.

Steve and Paul – who, after all, only ever wanted to be in a band – had made the decision to stay with their manager and carry on the Sex Pistols myth for whatever it was worth. To that end, they flew to Rio and ended up recording a new Sex Pistols

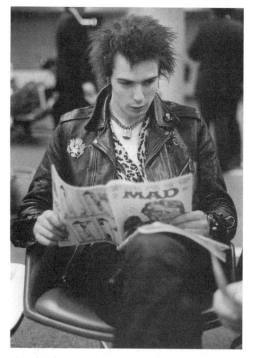

photo: Bob Gruen

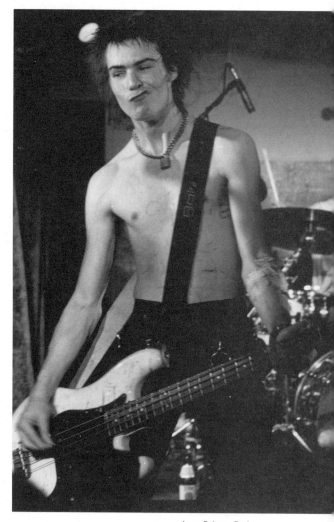

photo: Roberta Bayley

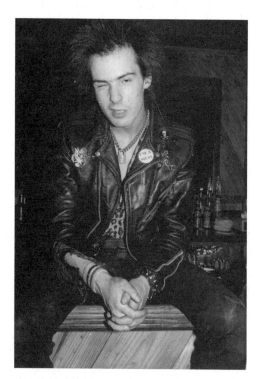

photo: Roberta Bayley

single without Sid and with a new vocalist, the aforementioned Ronnie Biggs. Sid, meanwhile, had gone off alone after the show. Nobody had a clue where he was until a fan turned up crying her eyes out. Sid had O.D'd. On this occasion, Boogie went to his rescue and was able to walk him around, put him in a cold bath and bring him back to life. But he was in no fit state to be used by anybody for anything. Any more talk of touring – with or without Rotten – was over.

Sid was taken by Boogie from Haight Ashbury to an alternative doctor in Marin County. He was given acupuncture and a bed for the night, while Boogie returned to the hotel and the news that the group he worked for had split up because Rotten had walked out. The following day Boogie returned to the doctor's surgery to pick up Sid. The acupuncture and a good night's rest had done him the world of good. It was almost as though the end of the Sex Pistols had given all the various group members their lives back.

Later that morning, Sid called John and told him he was disgusted with him. But, if anything, Sid was pleased that the group was over. Sophie took Sid to Los Angeles where she spent the whole day and night with him, never letting him out of her sight. The following day, January 18th, Boogie arrived to take Sid home. The first step was to see another doctor and get hold of the right drugs to get Sid through the next few days. The doctor in question prescribed methadone pills, so they took a flight to New York, first class, during which Sid passed out. Boogie was convinced he had taken something other than the pills, although they were all he had seen him take. With only a gap of three days between this and an overdose, Sid had now fallen into a semi-coma. Upon arrival at JFK airport, New York, Sid's condition was so bad that an ambulance crew picked him straight off the plane and rushed him to Jamaica hospital. A freak blizzard spread across New York over the next two days, meaning no flights in or out of the city. Sid was cut off from his fame and from whatever he saw as his position in the world. He was well and truly alone.

The only outside contact made with this very sick, very lonely 20-year-old during his stay at the Jamaica hospital, was a phone call from photographer Roberta Bayley on January 20th. During their conversation, she told him that, had it not been snowing, she would have happily visited him in hospital. For his part, Sid confessed that he

thought he would be dead within six months. At a mere 20, he hadn't known what it meant to be straight for going on four years. The following day he was, once again, met by Boogie and placed on a plane to London. The doctors had said he needed rest, good food, a full withdrawal and to lay off the drinking for a while. But he flew back into the waiting arms of Nancy and that particular prescription was unlikely to be available with her. It was more akin to force-feeding a vegetarian with McDonalds. In addition, a deep-seated hatred of his former best friend, John Rotten, was starting to take hold.

Within a few days of arriving home Sid, John and Malcolm had all given interviews to the UK press. The Sex Pistols were over and none of them cared too much. If anything, the whole thing had been a mistake. "I'm so glad I'm out of that group," Sid told Chris Salewicz. The question was: what would he do next? Indeed, what *could* he do next?

Chapter 15

Despite their joint resentment of McLaren, both Sid and Nancy always knew he would come through as their financial lifeline: they needed money to feed their habit and McLaren could be relied on for ways to eke out a few pounds. By this point, Rotten had declared in all interviews that he would have nothing to do with the movie McLaren was making about the group – a part-fact, part-fiction reworking of the group's story told through their manager's eyes. It had gone from being called 'Anarchy In The UK', to 'Who Killed Bambi?' and would eventually see the light of day years later as *The Great Rock' n' Roll Swindle*. From the day the group split, it was the movie that occupied McLaren's world. Sid decided that his best chance of any income was to do whatever he was called upon to do for that movie.

Life in their new homestead at Pindock Mews was fast becoming junkie heaven for Sid and Nancy. An American film crew working on the movie *D.O.A.* paid them a few pounds for an interview. A very stoned Sid slept through most of it with Nancy doing the bulk of the talking. They had become totally dependent on each other and in doing so had cut out most of the rest of the world. "I rang one day, it was a Sunday, I said to them 'I'll come over and cook Sunday lunch, we can get together make a day of it,'" says Anne Beverley. "Nancy answered and told me they hadn't got up yet really, but it was a super idea and could they call me later. Then nothing happened till about ten o'clock that night when Sid rang and asked if I could give him twenty pounds because he had things to buy for Sunday lunch."

"Sid just fell into the role to be a rebel. Lots of kids will say they might not live past a

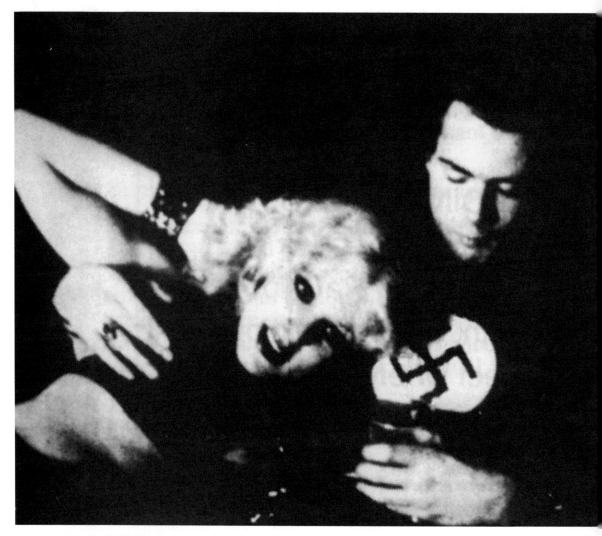

Interviewed at Pindock Mews

certain age and most of them are still working at wherever well into their adult life because they get past the point of rebellion. But, for Sid, there was no red light, only ever green. He bought the whole thing and in the end it was all he needed to destroy himself because he thought that's what people expected from him." (Nils Stevenson)

McLaren had planned another Sex Pistols line-up change, although now Sid would be the singer; but the growing strategic importance of his movie – his message to the world – put this plan on the back burner. But there was a solution; he had already filmed Steve and Paul in Rio with Ronnie Biggs and managed to convince himself that he could still film Rotten, maybe in some exotic setting like Cairo or Delhi. While that was all coming together, why not film Sid in Paris? Sid had by now already filmed

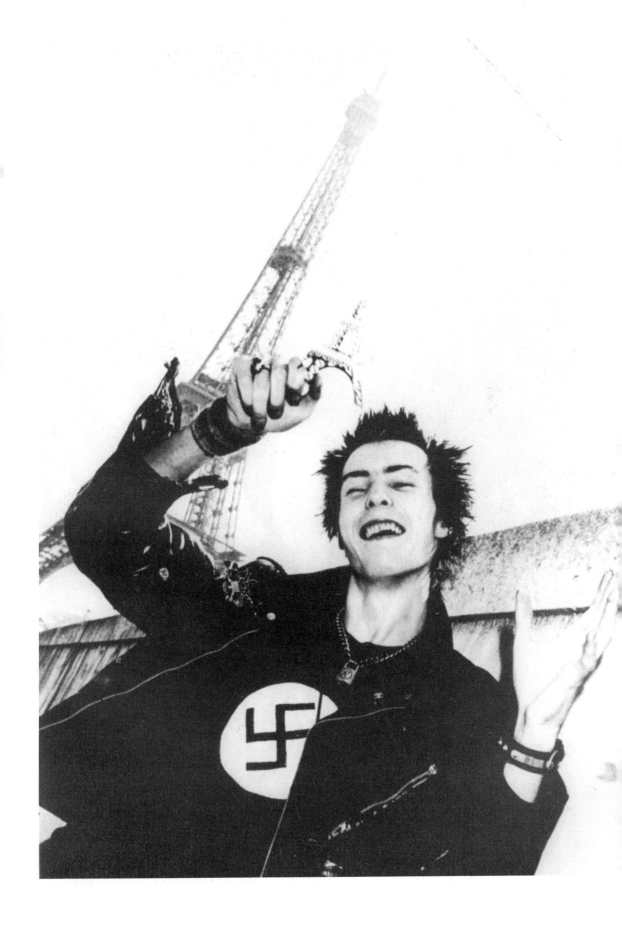

Sid and Nancy in Paris (photo:
John Tiberi)

VICIOUS TOO FAST TO LIVE

The 'My Way' video

some scenes for the movie, including a clip on a Jubilee stall giving away Sex Pistols merchandise to stray punters, but Paris was going to be different. This time he would film a scene and sing.

The film team with Sid and Nancy in tow flew to Paris in March 1978. The original idea had been to get footage of Sid in the Jewish quarter, walking around in a swastika T-shirt with him singing 'Je Ne Regrette Rien', although he thought the song was crap. It was replaced at the last minute by 'My Way', which Sid arranged himself, starting slow in a piss-take of Sinatra and ending fast in tribute to his beloved Ramones. Because he had started out a Sex Pistols fan, Sid was now in his element, carrying the group on his smack-ravaged shoulders. Everything in Paris should have been cool – a quick trip to make part of a movie. It should have been easy as... piss!

Nancy sent the following postcard to her mother from France: 'Love Paris. It's a really beautiful city with pretty parks and squares. Have been here for 3 weeks, so we had a

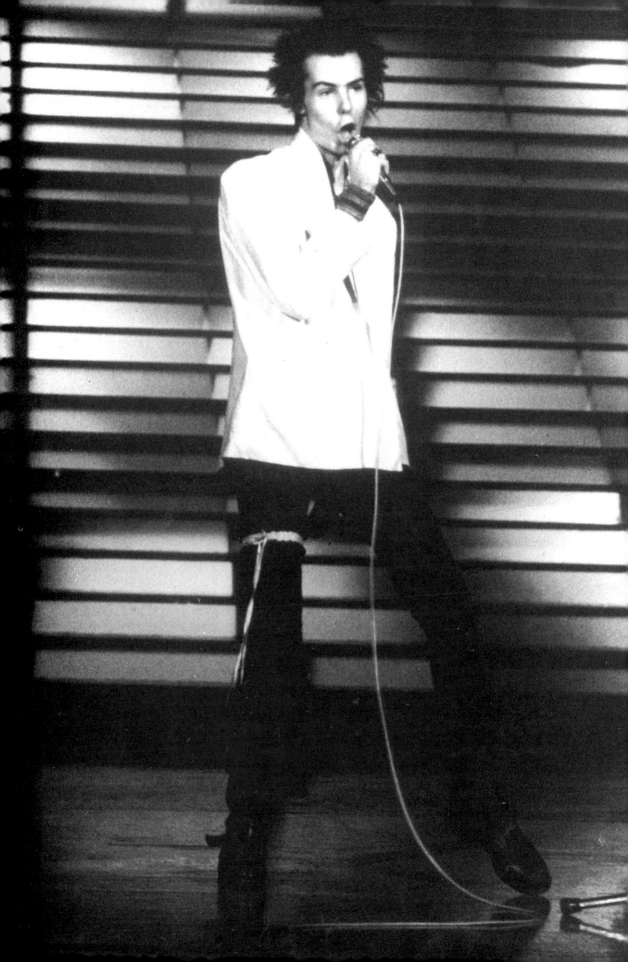

chance to really look around. I bought so many things – clothes, French make-up, jewellery, etc. Send my love...' Like most notes home from Nancy, it was a heavily embellished version of reality.

Sid made it to Paris under a cloud of heroin and methadone with Nancy joining him – something he could now control because he was calling his own shots. They cooked up a plan that she should be his manager, so Sid told McLaren that he would only shoot the 'My Way' scene if McLaren signed a piece of paper saying he no longer managed him. Thus Paris became harder work than it should have been because Sid spent time falling out with McLaren over everything. Finally, with Sid in his black jeans and bike boots, plus a white tuxedo, he filmed the song to an empty theatre, finishing off by shooting some of the imaginary audience at the very end – the audience would later be filmed one afternoon in April at the Screen On The Green in Islington. One of the key audience members to be shot by Sid was intended to be his mother. "Malcolm rang me one night. He told me he wanted Sid to shoot me in the movie. I told him he could go and fuck himself. They used someone else who didn't look one bit like me, but because no-one had seen me anyway, they all believed it was me. Years later at Virgin Records, someone said 'you've changed a bit since the movie.' I said, 'I was never in the movie.'"

In June that year, Virgin issued a new Sex Pistols single. It featured Ronnie Biggs singing 'No-One Is Innocent' on one side with Sid performing 'My Way' on the other. It was issued as a double A-side. The single shot up the UK charts in no time, not based on the myth of the group, nor particularly the addition to their line-up of a Great Train Robber, but on the fact that Sid Vicious, who always should have been a front man, had proved he really could carry it off without any problems.

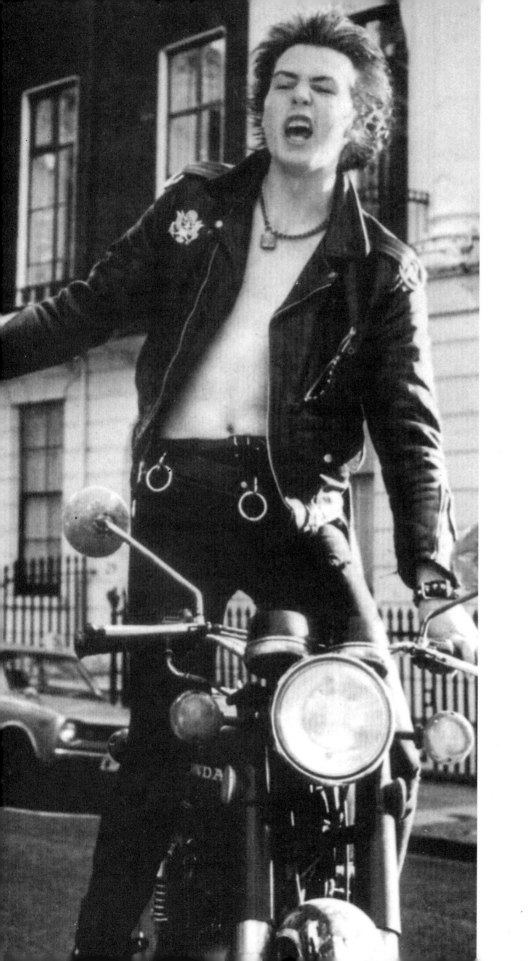

Chapter 16

In early August, Sid would run through his final duties as a Sex Pistol. First of all, it was decided to hold an audition for a new singer, even though the group by this point didn't look like lasting out the year in any format. The Duchess Theatre in the West End was booked with Steve, Paul and Sid running through a new song, 'The Great Rock n' Roll Swindle', while a number of hopefuls tried to sing it. This would all be filmed for the opening scene of the movie. A hundred hopefuls were auditioned and filmed that day – Edward Tenpole came along and made the best impression and would be the only one to be asked back and shoot more of the movie, as the more street Eddie 'Tenpole' Tudor. In the end, after two lead vocals, he even managed to carve a brief career out of it in the early 80s with the likes of 'Swords of A Thousand Men'.

Later that same week, Sid would record and film versions of 'Something Else' and 'C'mon Everybody' for the movie. With these complete and in the can, he could finally turn his back on the Sex Pistols for good. The first talk beyond this was that he would form a group with Johnny Thunders called The Living Dead and, while the name was undeniably spot-on, neither Sid or Thunders could bring themselves to push it any further than just talk. At least his last few weeks of Sex Pistols duty had kept himself and Nancy in a fairly calm state. But once that was over boredom set in, meaning more heroin and, in turn, more trouble.

"I went along to the studio when he recorded 'C'mon Everybody'. He was very happy that day, but for the first time I realised that this was everything for him; beyond being

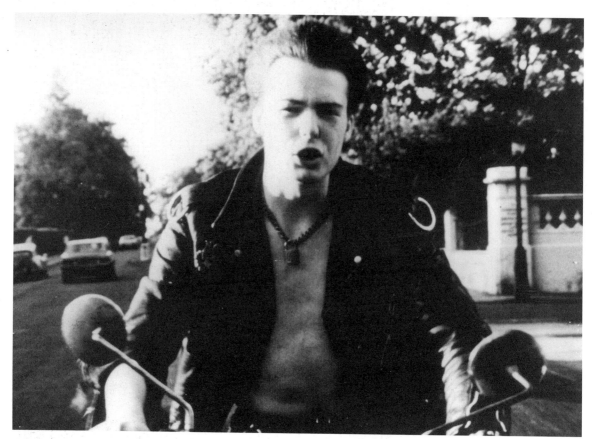
The 'C'Mon Everybody' video

a rock star there was nothing for him and it didn't seem like anybody was going out of their way to hire ex-Sex Pistols, so I did start to panic, I thought, beyond this, what is there for him? And then, of course, Nancy had her plan." (Anne Beverley)

At this time, fighting was commonplace in some of London's seedier rock'n'roll haunts, like Dingwalls and The Speakeasy. There were fights where Sid took on Paul Weller, Jimmy McCullough (from Paul McCartney's group, Wings) and a Marine on leave. He lost all of them and the last one left him with a right eye he would never fully open again. Nancy covered her battle scars in make-up, but Sid was losing it. The drugs had taken their toll on his looks and he'd got himself a paunch, not what you might expect of a 20-year-old. In mid-August, the pair got an even bigger shock when their friend John Shepcock overdosed on cocaine at their Pindock Mews flat and died. Such was their joint state that it took them half a day to realise they were sharing their bed with a corpse. The wake-up call was duly delivered and a joint decision to quit

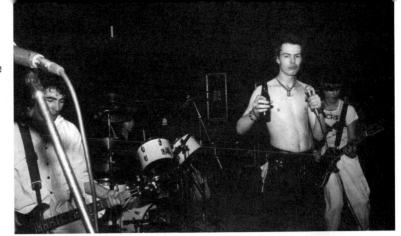

The Vicious White Kids – back-stage and onstage. The only time that Sid and Glen would appear live together

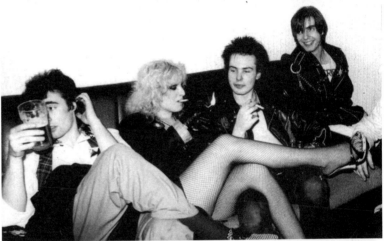

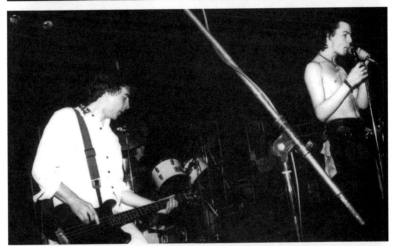

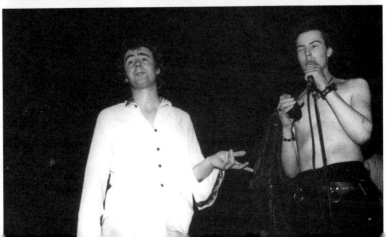

heroin – via heroin substitute methadone – was made. The downside of methadone is that it is as addictive as heroin. It didn't help that the pair had such large habits and that they were given the maximum dosage of methadone allowed.

Next, they would leave the UK and kick-start Sid's career again in the USA, specifically Nancy's adopted 'home' of Manhattan in New York. But for this they would need some money. One night in a Maida Vale pub, after a chat with fellow ex-Sex Pistol Glen Matlock, the decision was made for the two ex-Pistols to play a gig together; everything was arranged in quick time. Matlock laid down his terms first and said he would play bass (a wise move in any language) with his fellow ex-Rich Kid, Steve New, on lead guitar. Rat Scabies (originally of The Damned but currently with his own outfit The White Cats) would play drums. This left Sid with the position of singer and Nancy in a self-appointed call to arms as backing singer – although on the night one of the roadies had the brilliant idea of not actually plugging her microphone into anything.

This one-off punk supergroup would play their only ever show (although from the number of times it's appeared on album, you would swear they must have toured!) at The Electric Ballroom in Camden under the name The Vicious White Kids. They played a set of covers based around the three songs Sid had recorded for the movie and – because they went down better than they had expected – most of the songs were played twice! The gig was played on August 17th 1978 and, later that week, Sid and Nancy departed for New York.

"I was invited to the Camden gig but I was so unsure of what I'd be going to, I stayed away. Besides, the fact that I knew they were due to leave on the funds raised from the gig made it a very sad time for me. I was sure I wouldn't be seeing at least one of them again. I would never have guessed that things would turn out like they did." (Anne Beverley)

Chapter 17

"Poor Nancy," says Anne Beverley. "Poor, poor little Nancy. She told everybody she met that she wouldn't live to be 21, she made as many people as possible be against her, by treating them badly, but nobody deserves to end their life like she did. She was just a baby, one of two babies who never got much of a chance from the world." She bows her head in her chair and cries. At these times I always feel helpless. I head for the kitchen and make coffee for no other reason beyond... that's what people do at these times.

Sid Vicious arrived in New York along with his girlfriend/manager and fellow traveller Nancy Spungen. They took a cab to West 23rd Street and the rundown, rock'n'roll-friendly Chelsea Hotel, where they booked a room and decided to call it home. At the time, The Chelsea – with its seventeen pounds a night double room tariff – was the perfect hang out for junkies and street people. Their original idea had been that they would move to the USA, Sid would become a huge star, they would get off drugs, they would be married and New York would prove the perfect home. But, as with most of their previous plans, they hadn't done a great deal of thinking this one through.

First of all, the Sex Pistols hadn't been that big in America, and certainly hadn't played in New York. Sid was taken at face value and trips to the methadone clinic meant fights with other junkies because this guy was 'Vicious', a punk and a celebrity! To add to this, New York punks had never exactly rolled out the red carpet for London punks, even so-called famous ones so, in effect, they were in the enemy camp. While neither of them had yet hit the age of 22, they were effectively trapped in a dangerous world of their own making. A fuse was waiting to be lit.

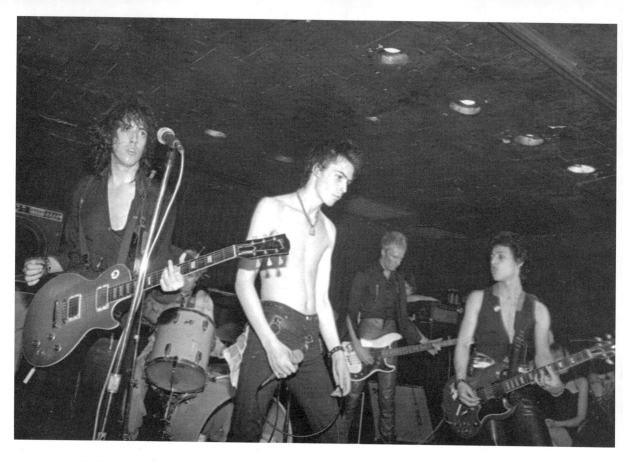

Live at Max's Kansas City with Mick Jones (top), 7/9/78 (photos: Stephanie Chernikowski)

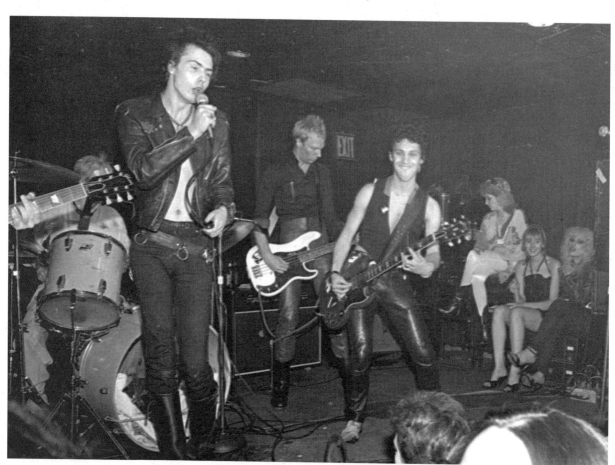

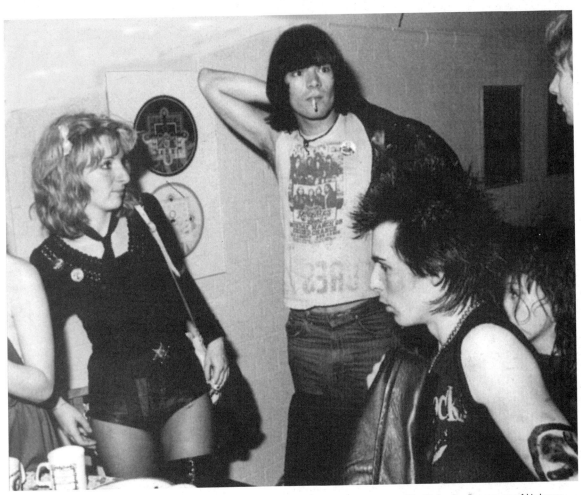

Sid with Dee-Dee Ramone, one of his heroes

Nancy did come good on her promise and via a few meetings with low-grade agents, she did pull together a few gigs; most of these allegedly costing her a blow-job and, at best, delivering Sid the door take on the worst night of the week. Almost all of these were played with a pick up band including: Jerry Nolan and Arthur Kane (ex-New York Dolls), Steve Dior on guitar and, on one occasion when he was in New York mixing the next Clash album, Mick Jones who played at one of the Max's Kansas City gigs (September 7th 1978). The people who came along to those shows – at first packed out and later barely half full – had come to witness a real life Sex Pistol and see if it tied in with what they had read in *Rolling Stone* about how outrageous they were during their January 1978 tour. Unfortunately, the eight months between then and now had been like a lifetime in the world of Sid Vicious, so what they got in the main was

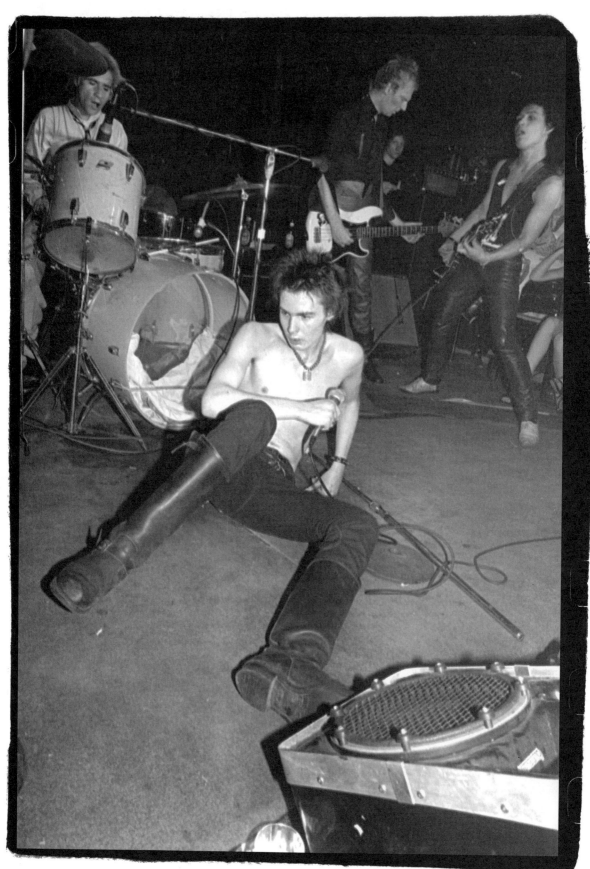

Photo: Stephanie Chernikowski

a young man old before his time going through the motions of a bunch of punk standards. Some nights his voice was great and thus so was the show, but on other nights his voice stank and he forgot the words to, among others, 'Belsen Was A Gas', which he himself had written.

After a short time, Nancy began to piss off some of the regulars at the clubs Sid was playing, but it didn't really matter too much by then because the New York music industry had already made up their mind about Sid Vicious: he was cut from the same cloth as The Heartbreakers and they had already written them off years earlier, so they filed Sid on the same page as them. Devastatingly, Warner Brothers (the Sex Pistols' USA record company) said no to any plans they might have and so the couple left New York to visit Nancy's parents in the appropriately named Main Line, Philadelphia. The couple that turned up at Deborah Spungen's family home were no longer just heroin addicts, they were constantly ill and hell bent on blotting out the world. Their daily routine included intakes of methadone, street heroin, Tuinols (barbiturates), Dilauded (a form of morphine given to cancer patients) and, if all else failed, vodka or schnapps in litre bottles. Nancy's mother describes the visit in her book as a hell on earth, but there was already worse to come.

Things had gotten very rough at the methadone centre so, after being told repeatedly by friends and Max's Kansas City manager, Peter Crowley, that he should get himself some protection, Sid bought a bowie knife at the end of September.

"I had received the odd phone call from New York, but then it went quiet. I thought to myself, still y'know, they said they had some gigs to do, so you might not hear straight away, but then it went very quiet and I started to get worried. It sounds strange, but I didn't know how worried to be." (Anne Beverley)

Before we go into the next part of the story, we must first address something which happened in the first week of October 1978. It doesn't crop up in many books, and newspaper reports of the events of later that month never mention it, yet it did happen. In that first week of October, Sid was telexed money by Malcolm for outstanding royalties and, along with the gig money he had been earning, the couple had amassed a total of almost twenty five thousand UK pounds. Sadly, their banking

skills were non-existent. They kept the money in the bottom drawer of room 100 in the Chelsea Hotel. Stiv Bators (ex-singer with The Dead Boys) would later tell me that this story made lots of sense, because in those last few days – the days before Nancy's death – they were anything but broke.

On October 11th Sid and Nancy had been spotted in the lobby area of the hotel, with an unidentified New York punkette. At about midnight, the girl left and the pair returned to room 100. Just after 1.30am Nancy made contact by phone with drug dealer Rockets Redglare (a police informer and heavy methadone addict), who had been spotted earlier that day by, among others, Neon Leon, in the bar at The Chelsea bumming dollar bills from musicians. Nancy requested that he bring over 40 Dilaudid capsules, which she knew would cost 40 dollars each. Rockets had nowhere near this amount in his possession, but did turn up not long after with a small amount of the drug. He stayed till somewhere between 4am and 5am, before agreeing to bring back more drugs for the couple.

As he was leaving the hotel, Rockets claims he saw another dealer, Steve Cincotti, arriving. Cincotti, who was known to be unstable, would later sell the most bizarre story of all those told in the aftermath to the infamous *New York Post*. It's claimed he sold the couple Tuinol, but a medical report from the next day will clearly show that there was none of this drug present in either Sid or Nancy. Neon Leon would also sell his own version of events to various magazines and would claim that Sid gave him all his possessions earlier that day and dismiss himself as a nothing and a nobody. But whether Sid even saw Neon Leon that day can't actually be corroborated by anybody who visited The Chelsea.

If Leon is right, then he was the last person to speak with Sid or Nancy and that was by phone. If Rockets is right, then he saw Cincotti arriving at the hotel, but the bell-hop on duty that night told police that no-one went to see the couple after Rockets left. We do know that Rockets arrived at the hotel sometime around 2am, we also know he left between 4am and 5am; a later police report will show that Sid took a large amount of drugs and was unconscious between 3am and 9am. If Rockets did lie about Cincotti – as the bell-hop's testimony indicates – then Rockets was the last person to see the couple while Nancy was still alive. Police believe Nancy died from

one single stab wound to the abdomen, sometime between 5am and 9am, which means she would have to have been stabbed during the period Sid himself was out cold. It is also true that whoever killed Nancy also robbed the couple of all but pocket change. Another fact pointing to the innocence of Sid.

But then we don't need too many facts pointing to the innocence of Sid because it's long been an open secret in the New York underground that Rockets Redglare, who died in 1999, told a number of people that he killed Nancy in order to help himself to the money in the bottom drawer.

Sid awoke at about 9.30am on October 12th to find a trail of blood from the bed to the bathroom. Slumped under the sink dressed in black bra and panties lay the dead body of Nancy. The other side of his two-people world – his soul mate – was dead. His knife had obviously been used to kill her, but he had no clue of the events leading up to this point: as indeed he wouldn't, having been dead to the world between the crucial hours of 3 and 9am. Meanwhile, on the lower side of the Bowery, Rockets, who had been bumming dollar bills the previous day, started the following one buying new leather jeans and cowboy boots.

Sid called for an ambulance, but the hotel bell-hop called for the police. In a confused post-narcotic state, Sid was arrested, handcuffed and taken to a holding cell at Third Homicide division on 51st Street. He is said to have 'confessed' to the murder with the words: "I did it because I'm a dirty dog." But in later interviews he will admit only to being out cold. Nancy's body was removed from The Chelsea Hotel at 5.30pm and by this time Sid had been charged with second degree murder. He would spend the rest of his life tormented, wondering but never knowing...

The Chelsea Hotel was besieged with onlookers, most of whom arrived in time to see Nancy being removed. All original reports from television, newspaper and radio had Sid charged as guilty of her murder. Back in the UK, Malcolm was informed by a telephone call from the *New York Post*. He rang Anne Beverley to tell her the news, then his friend and USA-based photographer, Joe Stevens, before boarding a plane and flying straight to New York.

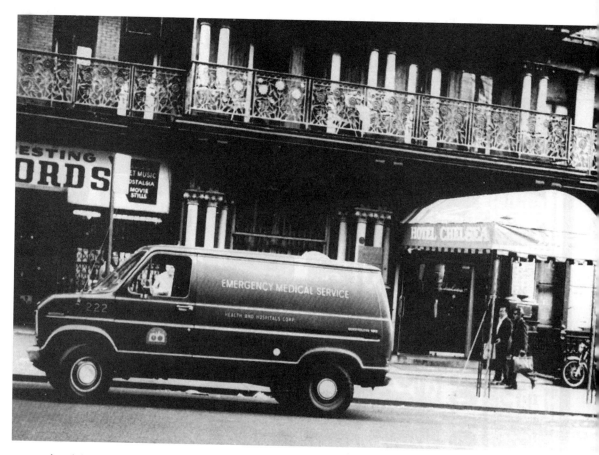
An ambulance takes Nancy's body from the Chelsea Hotel

"The phone rang that afternoon. It was Malcolm. I could tell he was under considerable stress. He didn't know how to break the news so he just came out with it. At that moment, that very minute, my world ended. It's never been the same since. I knew now that this story could never have a good ending." (Anne Beverley)

VICIOUS TOO FAST TO LIVE

Chapter 18

Warner Brothers Records were, of course still handling the Sex Pistols in the USA. They had a top team of legal people in the shape of Prior, Cashman, Sherman and Flynn. The following day they agreed a bail hearing and Sid was given bail at $50,000, but, after being charged with the murder of an American citizen, the terms and conditions of bail meant signing in at the nearest police station every day and a 'no bad behaviour' curfew. One strike and you're out, or back inside at least.

While Sid was in Riker's Island prison on remand, he sent two letters to Nancy's mum, Deborah Spungen. The first of the letters included the following poem:

You were my little baby girl
And I shared all your fears
Such joy to hold you in my arms
And kiss away your tears
But now your gone there's only pain
And nothing I can do
And I don't want to live this life
If I can't live for you
To my beautiful baby girl
Our love will never die

He would also make two phone calls to Deborah, both effectively promising that without Nancy he would not live. Both calls talked of suicide, the end was a matter of

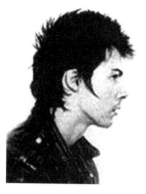
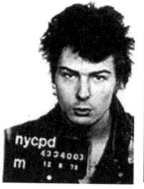
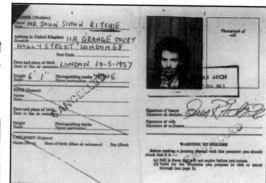

Sid under arrest

time away. He remembered nothing about the night in room 100. Everything was cloaked in shadow in his own world.

Malcolm had already got Richard Branson at Virgin to agree to standing the bail, on the understanding that once Sid was free, concerts and recordings would go some way to paying him back. The money was due to arrive from the UK on Monday October 17th. Sid's mum arrived in New York on the Sunday (16th) with a sleeping bag, a few numbers for bail hostels and a deal worth ten thousand dollars with the *New York Post*. On the same day, Nancy was buried at a private service in a Jewish cemetery just outside Philadelphia.

"Everybody we knew came together. 'Your son is in trouble, you must go and help him,' they said. Money came in from everywhere, all I could do was my best. Malcolm held everything together, he could talk, I thought he would make a difference. I went over just to be with Simon, that was my lot in life. Just to be there, smile and hold a few hands." (Anne Beverley)

With a possible sentence of 25 years hanging above him (earliest release date, late 2003), Sid was in no fit state to look after himself. Unfortunately, nor was Anne Beverley. Malcolm decided to take the bull by the horns and began to look into the whole thing deeper. He side-stepped the New York Police Department and brought in private investigators. He allegedly had the knife wiped of all prints, he tried to put together a more convincing account of events than the one the police had come up

with. On October 22nd in a deep depression and after taking that day's methadone, Sid tried to commit suicide by cutting his arms up with a broken light bulb and some razor blades. He was admitted to Bellevue Hospital. In the eyes of the press, this just made October 12th look like a suicide pact that had gone wrong.

Sid and Anne were booked into a low-rent welfare hotel called the Seville on Madison Avenue. It was here that Anne would discover the suicide note in Sid's jeans that was later published in my books *Sid's Way* and *Satellite*. From the hotel, Sid was on urine tests (for drugs) daily and the NYPD took his passport. He felt like he couldn't get out, like the walls were closing in on him, so it was here that he attempted suicide. But at least his mother had the sense to call Malcolm and Joe (Stevens). They arrived and try to put things right. Sid asked for smack to finish himself off, but Malcolm called an ambulance. Bellevue Hospital managed to repair the tortured former Sex Pistol and his ex-manager tried to talk some sense into him regarding the future – but Sid wanted a future with Nancy.

Back home in the Kings Road, Sex was now selling newly designed T-shirts featuring a picture of Sid surrounded by flowers with the words 'She's dead, I'm alive, I'm yours!'. In her new creation, Vivienne Westwood had finally found a use for the Sid character – so often labelled as useless – she had helped create. And the shirts were selling like hot cakes, while across the Atlantic the young man who had helped to inspire them was fast growing sick of life itself. Despite growing rumours of a Sex Pistols reunion gig to raise money for Sid, the only people to come out of the shadows and help him – beyond McLaren – were The Clash who, after a conversation with Anne Beverley, played a benefit gig for Sid in London on December 19th.

"Mick Jones always came through for him. You have to say, 'God bless Mick Jones' because he was a real mate. Anyone can talk about friendship, but when the chips are down that's when you'll know who your friends are and Mick was a mate. I just wish sometimes that Simon could have been a bit more like Mick as a person, but I'm not a dreamer." (Anne Beverley)

After a full psychological examination was made on him, Sid was discharged from Bellevue Hospital. His next court hearing was not due to take place until November

21st In the gap between leaving Bellevue and entering court, Sid found a new girlfriend, in the shape of Michelle Robinson, a fairly disturbed young woman who worked as an actress (though what in is anybody's guess) and had recently lost her boyfriend to a drugs overdose. The couple went straight back into the New York nightlife scene together and Michelle attended court with him on the 21st.

The District Attorney, Al Sullivan, agreed that the bail could stand so long as Sid made daily reports to New York Homicide Division and the methadone clinic. Sid was never brilliant at daily anything – with the one exception of drugs – and he'd been left in the care of his mother who, time would later reveal, could not properly look after herself. On the evening of December 9th, Sid and Michelle had a night out at Hurrah's, a disco club in Manhattan. Some time around 2.30am, Sid was confronted by Todd Smith, brother of Patti, whose girlfriend Sid was accused of chatting up. Smith threw a few punches at Sid, who retaliated the only way he knew how: by smashing a bottle and going for Smith. By the next day, 5 stitches meant Sid was back in Riker's Island prison, a maximum security holding pen for gang bangers and murderers.

This time around Sid's name really worked against him. Already in cold turkey, the other inmates wanted to know more about the guy who called himself Sid V-I-C-I-O-U-S. Over the next few days, Simon Beverley, who at 6ft 1 inch was a skinny-looking kid, and probably weighing in about seven stone – if he was in a solid brass diving helmet – was beaten, raped, beaten again and generally abused. Whoever chose to throw Sid – a sickly Limey punk pop star on a murder charge – into the hardcore hell of Riker's is anyone's guess. Horse-whipping would be too good for them, in retrospect (bear in mind that Mark Chapman, a clearly dangerous individual who a year later gunned down John Lennon in cold blood, was only placed in the much 'milder' Attica prison).

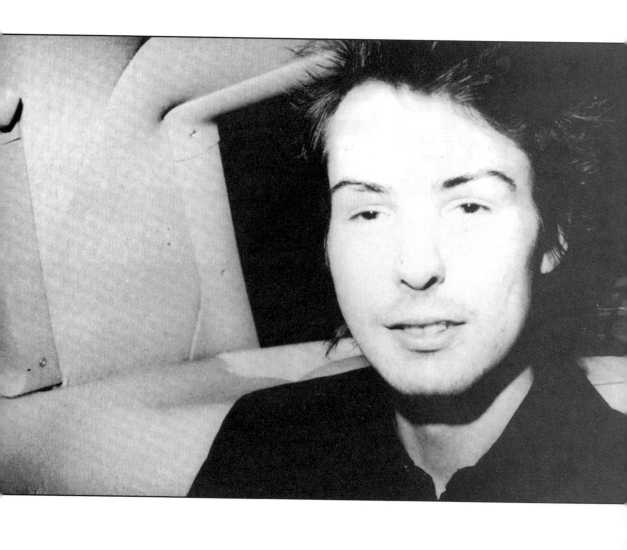

Chapter 19

Sid's next hearing was on December 12th, when it was decided that he would be switched from main population on Riker's to the hospital detox wing. This meant that at least they would know where he was while they were compiling reports on him. A further hearing was set for January 31st, so Sid would spend Christmas inside. Over the festive season a plan was made back home by McLaren. Obviously more money would be needed to stand new bail in the coming year. He approached Richard Branson, who informed him that unless something was delivered product-wise, there would be no more money from him. Thus was created another new money-spinning plan: Malcolm would fly to New York with Steve and Paul, to record an album of covers and rock'n'roll standards. The upfront money on this project would stand Sid's bail.

A decision was reached for the three of them to fly out on February 4th 1979. This should easily be in enough time because the hearing wasn't due to start till February 1st. But this plan only worked if the hearing went on for a few days. A cleaned-up and totally refreshed Sid arrived in court with his lawyer, James Merberg. While he had been away, evidence had been gathered together to suggest that Sid might have been in with a chance. There were so many inconsistencies, and hopes of an acquittal were high. Merberg worked fast. By lunch-time Sid was free and right back into company consisting of Michelle, his mother and... the collective New York drug set.

At CBGB's club on the Bowery that night, Rockets Redglare would once again become drunk among a crowd of musicians and, once again, boast of the murder of Nancy. But, as with most of the parts of this story on other occasions, no-one came forward.

Sid with Michelle (left) and friend; less than 24 hours later he would be dead

Meanwhile, Sid and the group of friends he'd met outside the court headed back to 63 Bank Street, Greenwich Village, which was Michelle's flat. A small crowd of about eight people had been invited back by Anne Beverley, whose idea it had been to turn the evening into a celebration of her son's release. She had made a meal of spaghetti bolognaise in his honour and pitched up for some beers.

Despite cleaning up during his second stint in prison, Sid had taken some smack early on his day of release, given to him by a fellow addict called Martin. But it must have been cut with everything but heroin, because he didn't get a hit from it. NYPD records clearly show that almost all street heroin sold between Christmas 1978 and Easter 1979 was cut down to between 32% and 36% pure.

Sid was a 'name' and it wouldn't be appropriate for him to go looking for drugs, because he would no doubt get nicked just for being Sid. So that evening Martin again went to buy the heroin alone, while Anne cooked a meal. It later turned out through a friend of Anne Beverley that Martin bought the heroin that night from a dealer who had been supplied by Rockets Redglare. News on the street was that this hit was going to Sid Vicious.

About a quarter of an hour after the meal, Sid and a few of the guests present went into the bedroom. They took some of the newly-purchased heroin and when they returned to the room Anne noticed Sid had a rose pink glow about him. Anne, despite being an ex-addict herself, had never seen anything like it. She later said: "Jesus, son, that must have been a good hit." Those present remember he looked elated. A few moments later, Sid went back to the bedroom with Michelle, but Michelle returned on her own. Sid had collapsed. He was falling off the bed. No-one was 100% sure what to do – this was Sid Vicious, remember? Do you take him to hospital, or do you just help him the best you can without drawing attention? Anne went into the bedroom and placed him on his side so he could sleep it off. Eventually he came round. Anne told him how worried she had been, but Sid insisted he was fine, didn't want to do anything but go to bed, which was a good idea anyway because he had to check in at the local police station early the next morning.

Anne took the rest of the heroin from them and placed it in her back pocket. She slept on the sofa and the rest of the guests left the flat. Whether Sid stole the rest of the heroin from his mother's pocket that night, or whether he simply fell into a relapse is not known. He had been off drugs for a while and cleaned up perfectly in Riker's. Sometime during the night he fell into a coma and died. He had, without ever knowing it, taken a 'hot shot' – 98% pure heroin.

Although Sid's death is generally accepted as an accidental overdose due to his detoxed state, there is another possible spin which leads us into the realm of a double murder. If this fix was, as Anne was later told, supplied via Rockets Redglare, then not only had the dealer killed Nancy, but he had also just gotten rid of the only person in the frame for her murder, leaving him to go about his business, both 'innocent' and free. Basically, Sid was denied the chance to be proved innocent, which would have

WE HAD A DEATH
 PACT
I HAVE TO KEEP
MY HALF OF THE
BARGAIN.
PLEASE BURY ME

PTO

NEXT TO MY BABY.
BURY ME IN MY
LEATHER JACKET,
JEANS AND MOTOR
CYCLE BOOTS

 GOODBYE

turned police attention to the other players involved that night; and when the accused in a murder case died before trial, that was pretty much the end of the investigation – and so it turned out in the Nancy Spungen affair.

Anne Beverley knew her son could not face doing time in any of America's tougher prisons; in that sense, she was actually glad he died. She was a huge believer that everybody meets up again on the other side, so she was sure that Sid was safe with Nancy. It was after she told this story to movie-maker Alex Cox (who produced the film *Sid & Nancy*) that he re-wrote the dream scene ending. Anne liked the idea.

But Sid's death, while expected by all those around him, pulled the rug out from underneath her. He was 21 years old and he was gone. From the day he had been re-christened Sid Vicious, Simon Beverley seemed to want nothing more than to live up to the name. It was a mission that ultimately killed him.

If they did have a joint suicide pact – and the note which I first became aware of when it fell out of the back of Sid's passport at his mum's home, does indicate quite clearly that they did – then they obviously succeeded in their wish, albeit with the 'help' of others. They shall remain forever the stuff of T-shirts and posters, like James Dean and Marilyn Monroe they are trapped forever in premature and tragic death and the ensuing hero worship. Live fast, die young and sell lots of merchandise. It will always net millions, but admission to this exclusive club is pricey: you have to die to get in.

Three weeks after Sid's death, Virgin Records – who have always maintained that the release date was chosen in November 1978 – released 'Something Else', a re-working of the Eddie Cochran classic by Sid. Within a couple of weeks it had sold 382,000 copies, which is almost double the number sold by 'God Save The Queen'. On February 7th Sid was cremated in Manhattan. It had always been his wish to be buried with Nancy, but despite attempts by Anne to contact Deborah Spungen and organise this, all requests were turned down. For a start, Nancy was buried in a Jewish cemetery and non-Jews cannot be buried in sanctified ground. Furthermore, as Anne and I discussed later, it's not the easiest of jobs trying to get someone buried with their former girlfriend when they've been accused of killing her.

One of the stories regarding Sid's ashes, as told more often than not by John Lydon, is that they were dropped at Heathrow airport by Anne and he's been floating around ever since. But this story isn't remotely true. The facts of the matter are that in the week following February 7th Anne, her sister and Eileen Polk (a photographer and friend) drove to Philadelphia. They made some checks before their visit and found there is only one Jewish cemetery. While Eileen kept watch at the gates, Anne and her sister found Nancy's grave and sprinkled Sid's ashes across the ground. "She came back crying," said Eileen Polk. "At least they're together now, and no-one can part them."

"Every gimmick hungry yob digging gold from rock' n' roll, grabs the mike to tells us he' ll die before he's old. But I believe in this and it' s been tested by research, that he who fucks nuns will later join the church." (from 'Death Or Glory' by The Clash)

Chapter 20

Michelle Robinson never sold her story to anyone. I have followed many leads over the years and still cannot tell you whether Michelle is alive or dead, she just seemed to sink back into New York life. Anne Beverley and I often spoke about Deborah Spungen. Anne said she would love to have had longer chats with her – they were certainly the only two people in the world who could be expected to understand each other's situation – but at the end they were left in a position where conversation would have been impossible. Anne read Deborah's book and enjoyed it, she said it got some honesty across.

One year to the day after Sid's death on February 2nd 1980, punks took to the streets of London and marched in his name. Anne Beverley was invited but failed to attend because, she told me, the weather was bad. She did wish them luck, however. On January 13th 1986, a full seven years after the death of her son, Anne attended The High Court building, in central London, for the case of Glitterbest (McLaren) V Lydon. Three days later the case came to a halt. John Lydon, Steven Jones, Paul Cook, Simon John Beverley and Glen Matlock won. The movie made in their name, *The Great Rock' n' Roll Swindle*, along with a sum of eight hundred and eighty thousand pounds – for the sake of argument a cool million – in lost earnings were theirs. Anne Beverley, as head of the Sid Vicious estate, would now get an equal split of all Sex Pistols earnings. She decided the time was right to hide herself away from the world.

Later that evening she threw a dart into a map. It landed on Swadlincote, just outside Burton, over the Trent bridge. She visited the following week. By the end of the month

she owned a house there; nobody knew where she was and that suited her fine. With the publication of Deborah Spungen's book *And I Don't Want To Live This Life* – a line written by Sid in a poem about Nancy sent to Deborah from Riker's Island prison – Anne made the decision that her side of the story needed to be told. By all accounts, she only told one person of this decision and that was Vicky Mockett – the owner of design company, Not Why Not, who produced Sid merchandising on behalf of the estate...

In the early Nineties myself and Anne heard that Kurt Cobain and his wife, Courtney Love, had been checking into hotels under the name Mr & Mrs J Beverley. Anne thought it was hilarious; indeed the day after Cobain's own early death, on a hillside just outside Seattle, a fan carved the words 'Simon John Beverley RIP'. Just to keep the ball rolling I booked myself into the Roger Smith Hotel in Manhattan, while researching more Sid material, under the name Simon Beverley. I felt Anne would have loved that.

One final thing: while I was looking through piles of old newspapers at Colindale Newspaper Library, I found a piece from the *New York Times*, written by their French correspondent and filed on Monday April 23rd 1866. It was regarding a young couple who made and carried out a joint suicide pact in her father's barn. He was aged 19, she was slightly older at just 21. Their names were... Sid and Nancy.

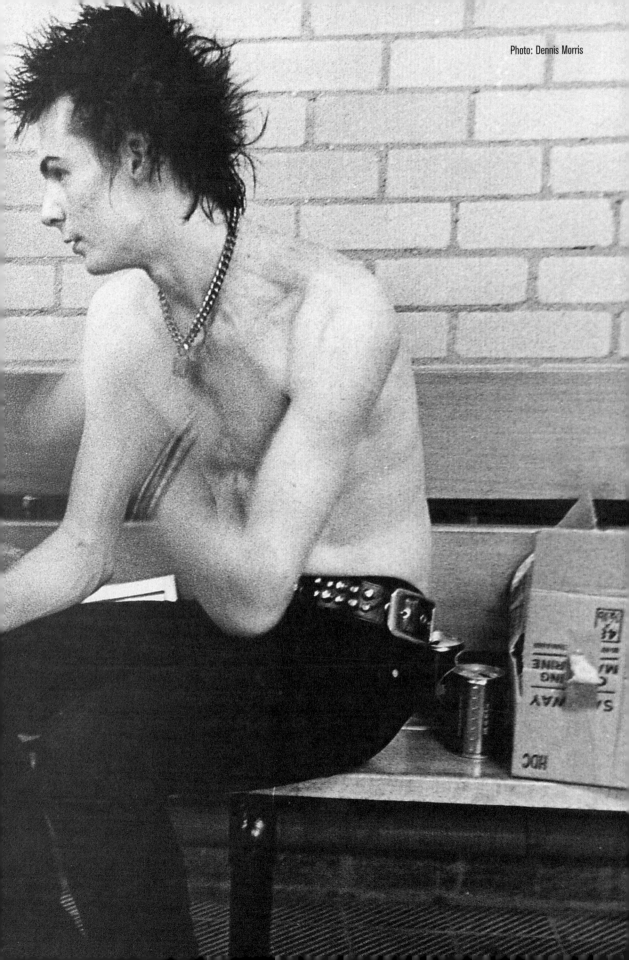

Appendix

PIZZAS FROM HELL AT THE KNOB END OF NOWHERE* (An Afterthought):

A number of years after the launch of the first Sid book – it had gone out of print – my reaction was fairly simple. Let's call time on it, put it on the shelf and move on. Only when I came to putting my copy on the shelf I noticed that the box that had contained a dozen copies was now empty. That very morning I became the punk equivalent of JR Hartley, a man with a book in print and no copy for himself. My first port of call was the publishers who, as you'd probably guess, had no copies left. I then scoured record fairs, bookshops, book fairs, small ads. Nobody was selling a copy either. I met people who owned a copy, I told them I wrote it, they said... mostly they said, 'can you sign mine?' Finally, I took out an ad in Scott Murphy's excellent Sex Pistols fanzine, 'The Filth & The Fury', in which I asked for a copy of *Sid's Way*; beyond that information, it just had my name and address. The upshot of all this was that I met Mick O'Shea and Brian Jackson. Between us we unfolded 100 Sex Pistols mysteries. We bought and swapped records, two of us (no, not you, Mick – you did exercise some intelligence on the day) went so far as to purchase Sid Vicious action men. And, finally, I got a copy of *Sid's Way*, which is why all that started in the first place.

The week we finished the original Sid book, myself, Anne Beverley and Keith Bateson met up in Swadlincote to photograph some of Sid's belongings. The local press from Burton interviewed us about the book and the forthcoming Radio 2 documentary on Sid. We then had lunch at the Little Chef, near the motorway just outside Burton. Anne said the Sex Pistols would never play together again. I wasn't sure and told her I was

still positive that, if ever the money was right, they would jump at the chance. Keith agreed saying he thought the first significant anniversary of punk would be a cool time – turns out he was 100% right on the money.

Over the following years, many punk fans begged me to take them to Swadlincote. They just wanted to meet Sid's mum, see his bass guitar – the very guitar I'd been the only person in years ever to play – and talk a few things over. One mate of mine got so pissed on a Saturday night out that he offered me 200 pounds in cash, and a lift in his car, just to meet Anne Beverley! But I knew Anne loved her privacy. Whenever we had any business – and, due in no small part to the book, we always had business, from posters to T-shirts via CDs – they all needed Anne's approval. As I was the only inroad to her, I would take all the ideas to her personally. I went alone every time with one exception and, on that occasion, I took a girl, who like all girls at the time, I thought the world revolved around. It didn't.

About two or three times a month, Anne would ring my mum. They would talk about all kinds of everything and, of course, they always had punk rock in common if the conversation ever fell short. I found out Anne was dead via a telephone call from Pete Silverton, Glen Matlock's biographer. He rang me for a quote, which was later used in an obituary piece that went round the world. Two days after her death I received a letter from her (testimony to the wonders of the British postal service!). She told me how she had given up on everything, and above all wanted to be with Simon. The very same Simon she had spent a third of her life missing. She told me never to give up on any dream I might have, and only ever call it a day when the job was done. She asked that if I ever got any more information on Rockets Redglare, no matter how long after her death, I do the right thing and publish it. Here, after all, was a man who had ruined life for two families and walked away from his actions, free to the day of his own death. Anne's death made every national newspaper, something she would have been more than surprised by; she was always aware of Nancy's true murderer and told me that one day the time would be right for everyone to know. I hope she would believe now was that time...

I now live in Maida Vale, London – an area often described to me by Anne. What's more, I live just around the corner from Pindock Mews, the former home of Sid and

Nancy. It's funny but on sunny Sunday afternoons when couples stroll to any one of the local pubs, or families chill out in their basement flats, while Dad washes the car outside, I walk past them all to Warwick Avenue tube station, just smiling to myself and picking out two ghosts from an era I've only ever had described to me...

* "Pizzas from hell at the knob end of nowhere," was a quote from my good friend, Mick O'Shea, one cold winter evening after a night out that went wrong. Let me explain myself: Mick and Brian Jackson had been drinking in my hometown of Blackburn, and another pal of mine, Dave Henderson, had said we should all meet up later that evening at his place, in the small village of Mellor, just outside the town. Not wanting to turn up empty-handed, we bought some beer, a large 20" pizza for the four of us and hopped into a taxi. When we arrived in Mellor, Dave, who by now thought we weren't coming, had gone out. Taxis don't run through Mellor they must be ordered, it was freezing, the pizza we ordered was not the one we'd been given – a simple mix up – and we were stuck up the creek without a paddle, hence the quote...

About the Author

Alan Parker lives in the Madia Vale area of London. He is 38-years-old, and embraces all aspects of music. He has contributed to: Record Collector, Ice, Spiral Scratch, Bizarre, Kerrang!, Mojo and Loaded. He is acknowleged as an expert on the subject of punk and new wave music and – to that end – works on albums for EMI Records, Universal Records, Sanctuary Records, Strange Fruit and Secret Music. His previous published books include:

Satellite (Abstract Sounds Publishing) with Paul Burgess
Stiff Little Fingers: Song By Song (Sanctuary Publishing) with Jake Burns
Hardcore Superstar: The Traci Lords Story (Private Publishing) **USA Only**
Rat Patrol From Fort Bragg (Abstract Sounds Publishing)
John Lennon: The FBI Files (Sanctuary Publishing) with Phil Strongman

The Sid Vicious tattoo on his left arm was drawn from a photo by Bob Gruen by Goz at Eagles Wings Tattoo Studio, Blackburn, Lancashire. It won a prize at the Birmingham Tattoo show in 1995 and was bought and paid for by Anne Beverley.

Sᴵᴅ Vɪᴄɪᴏᴜs Dɪsᴄᴏɢʀᴀᴘʜʏ

Singles

No-One Is Innocent/My Way (Virgin Records) 1978.
Double A side single, with Sid handling 'My Way'

Something Else/Friggin' In The Riggin' (Virgin Records) 1979.
Sid gets the A side and outsells 'God Save The Queen'

C'mon Everybody/God Save The Queen (symph)/*Watcha Gonna Do About It*? (Virgin Records) 1979.
Sid's final A side

Something Else/C'mon Everybody/My Way (Barcley Records) 1979.
French 12" single collecting up all Sid's lead vocal performances

Albums

Vicious: Too Fast To Live... (EMI Records)

Sid Sing's (Virgin)
Original copies came with one of three posters, one of which (*Swindle* stall poster) is ultra rare

Sid Dead Live (Anagram Records)

Vive Le Rock (Alchemy Entertainment) 2 x CD

Vicious White Kids (Sanctuary Records)

Defendant(s) John Ritchie aka **Sid Vicious** Ind./Docket No. **N 867406** Ind. **#4529/78**

Date Prepared **11/22/78** by ADA **Sullivan/Schachter**

1. Occurrence: Date **10/12/78** 2. Arrest: Date **10/12/78**

App. Time **Morning** App. Time **Afternoon**

Place **Chelsea Hotel** Place **Third Homicide**
222 W. 23 Street

3. ITEMS (IF ANY) SEIZED FROM THE DEFENDANT(S), WHETHER OR NOT CONTRABAND, INTENDED TO BE OFFERED BY THE PEOPLE AT TRIAL:

Knife, Works (hypo, etc) clothing, blood samples, other personal property

found at scene. A more complete list will be prepared.

4. NAMES, SHIELD NUMBERS, COMMANDS OF ARRESTING OFFICER AND OTHER POLICE OFFICERS VITALLY INVOLVED IN THE ARREST OR PRECEDING POLICE WORK:

Det. Gerald Thomas 1893-3HZ Sgt. Thomas Kilroy 1715-3HZ

P.O. William Sportiello 23218 -10HZ

5. /X/ IF CHECKED, NATURE AND EXTENT OF THE INJURIES AND PLACE AND EXTENT OF MEDICAL TREATMENT FOR ANY INJURED PERSON OTHER THAN THE DEFENDANT:

Dead at scene

6. /X/ IF CHECKED, PEOPLE INTEND TO INTRODUCE STATEMENTS MADE BY THE DEFENDANT(S) PURSUANT TO SECTION 710.30 (1) (a) OF THE CPL. SUCH STATEMENT APPENDED, or /__/ LISTED IN ITEM 21 BELOW.

7. /__/ IF CHECKED PEOPLE INTEND TO INTRODUCE IDENTIFICATION TESTIMONY BY A WITNESS WHO HAS PREVIOUSLY IDENTIFIED THE DEFENDANT, PURSUANT TO SECTION 710.30 (1) (b) OF THE CPL:

Type of Identification:_____

Date Made:_____ Place Made_____

8. PURSUANT TO SECTION 250.20 OF THE CPL, THE PEOPLE HEREBY DEMAND THAT DEFENDANT SUPPLY THE DISTRICT ATTORNEY WITH (a) THE PLACE OR PLACES WHERE THE DEFENDANT CLAIMS TO HAVE BEEN AT THE TIME OF THE COMMISSION OF THE CRIME AND (b) THE NAMES, RESIDENTIAL ADDRESSES, THE PLACES OF EMPLOYMENT AND THE ADDRESSES THEREOF OF EVERY ALIBI WITNESS UPON WHOM THE DEFENDANT INTENDS TO RELY TO ESTABLISH HIS PRESENCE ELSEWHERE THAN AT THE SCENE OF THE CRIME AT THE TIME OF ITS COMMISSION. WITHIN A REASONABLE TIME OF THE RECEIPT OF THE LIST SPECIFIED IN (b) ABOVE, THE DISTRICT ATTORNEY WILL SUBMIT A LIST OF ANY REBUTTAL WITNESSES, THEIR ADDRESSES AND EMPLOYERS:

VOLUNTARY DISCLOSURE SHEET SUPPLEMENT

Defendant made various statements to police officers and detectives at the Hotel Chelsea.

To the first police officers he said in substance that:

> He didn't know what happened - he wasn't there.
> He discovered the body about 10:30 AM.
> He wished they would shoot him or kill him.
> He also identified himself and the deceased.

To the detectives he said in substance that:

> He and the deceased had taken tuinal that night and he went to sleep about 1 AM. Nancy was in the bed with him when he went to sleep. Nancy was sitting on the edge of the bed flicking a knife. They had had an argument.

> He claimed when he woke up in the morning the bed was wet with blood. He thought he had "pee'd" himself. He found the deceased in the bathroom sitting on the floor (same position as found by police). She was breathing. She had a stab wound in her stomach.

> He left her. He went out to get her methadone - at Lafayette Street. When he returned she was full of blood. He washed off the knife and he attempted to wash her off. When he could not wash the blood off her he called for help. He did not know what happened to her. He had slept the entire night through. At various times he said "my baby is dead" or words to that effect. He denied stabbing her (various times).

> The defendant also said that he did not remember what their argument was about and that she hit him and he hit her, on top of the head and knocked her onto the bed - but he did not knock her unconcious. He said "I stabbed her but I didn't mean to kill her. I loved her, but she treated me like shit."

> At other times the defendant said the deceased must have fallen on the knife and that she must have dragged herself into the bathroom.

> When asked why he left the deceased in the bathroom, wounded, and went out to get his methadone he said "Oh! I am a dog" or similar words.

Criminal Court of the City of New York

Part _____ County ___NY___

THE PEOPLE OF THE STATE OF NEW YORK
vs.

1. __John Ritchie__
2. _____
3. _____
4. _____

DEFENDANTS

STATE OF NEW YORK } SS.:
COUNTY OF ___NY___

Det. Kaercher # 2208 _____ of _____ 20th Ptl. ___NY___ ___NY___

being duly sworn, deposes and says that on ___12-8-78___ at about ___1:35 a.m.___

at ___36 W. 62nd St.___ ___NY___ , State of New York,

the defendant committed the offenses of: *PL 120.10*

A. Assault 2nd deg. ~~PL 120.05 F~~
B. Possession of dangerous instrument PL 265.01
C. _____
D. _____

in that said defendants

under the following circumstances:

Deponent is informed by Todd Smith of an address known to deponent and to the Assistant District Attorney, that at the above time and place, defendant struck informant in the face with a ~~broken~~ glass beer mug and kicked informant in the genitals, thereby causing serious physical injury requiring medical treatment.

Defendant made statements.

N881187

Sworn to before me on ___12-9-78___ ___19___

Judge

HERBERT I. ALTMAN

Deponent

FELONY COMPLAINT

FORM P-1 (Rev. 11/90/92) (7)

Form 18-46-18M-703P51(75) —●—346

SUPREME COURT OF THE STATE OF NEW YORK
COUNTY OF NEW YORK

KS:kd

THE PEOPLE OF THE STATE OF NEW YORK,

— against —

JOHN RITCHIE

also known as
SID VICIOUS

Defendant

THE GRAND JURY OF THE COUNTY OF NEW YORK, by this indictment, accuse the defendant

of the crime of MURDER IN THE SECOND DEGREE, committed as follows:

The defendant , in the County of New York, on or about October 12, 1978, under

circumstances evincing a depraved indifference to human life,'

recklessly engaged in conduct which created a grave risk of death

to another person, to wit, Nancy Spungen, and thereby caused the

death of Nancy Spungen by plunging a knife into her abdomen.

SECOND COUNT:

AND THE GRAND JURY AFORESAID, by this indictment, further accuse

the defendant of the crime of MURDER IN THE SECOND DEGREE, committed

as follows:

The defendant, in the County of New York, on or about October

12, 1978, with intent to cause the death of Nancy Spungen caused the

death of Nancy Spungen by plunging a knife into her abdomen.

ROBERT M. MORGENTHAU
District Attorney

CITY OF NEW YORK BUREAU OF VITAL RECORDS

Date: **MAR 7 1979**

CERTIFICATE OF DEATH 156-79-1(68)078

Certificate No.

DATE FILED
9 FEB 7... A9.07

1. NAME OF DECEASED (Type or Print)	JOHN	SIMON	RITCHIE
	First Name	Middle Name	Last Name

MEDICAL CERTIFICATE OF DEATH (To be filled in by the Physician)

2. PLACE OF DEATH	NEW YORK CITY	b. Name of hospital or institution, if not hospital, street address	c. If in hospital (Check)	d. If hospital, date of recent admission
	a. BOROUGH **MANHATTAN**	**63 Bank Street**	1 DOA 3 Outpatient	Month Day Year
	(Month) (Day) (Year)		2 Emerg. rm 4 Inpatient	

3a. DATE AND HOUR OF DEATH	3b. HOUR	4 SEX	5 APPROX. DATE AGE
February 2, 1979	**unknown** AM PM	**Male**	**21 yrs.**

6. I HEREBY CERTIFY that, in accordance with the provisions of law, I took charge of the dead body
OFFICE OF CHIEF MEDICAL EXAMINER on the **2nd** day of **February** 19 **79**
at 520 FIRST AVENUE, N.Y. 16, N.Y. I further certify from the investigation and post mortem examination ☒ with ☐ without autopsy that in my opinion death occurred on the date and at the hour stated above and resulted from ☐ Natural Causes ☐ Suicide ☐ Undetermined Circumstances ☐ Accident ☐ Homicide ☒ Pending Further Investigation

and that the causes of death were:

PART 1	a. Immediate cause	**ACUTE INTRAVENOUS NARCOTISM. PENDING CHEMICAL**
	b. Due to or as a consequence of	**EXAMINATION.**
	c. Due to or as a consequence of	

| PART 2 | Contributory causes | |

M.E. Case No.		
M-800	Signed _Michael Baden_	M.D.
	MICHAEL M. BADEN XXXXXXXXXXXXXXXXXXXXXXXXXXXXXXXX (Chief) (Medical Examiner)	

PERSONAL PARTICULARS (To be filled in by the Funeral Director)

7. USUAL RESIDENCE a. STATE	b. COUNTY	c. CITY, TOWN OR LOCATION	d. STREET AND HOUSE NUMBER	e. INSIDE CITY LIMITS OF 7c ☐ YES ☐ NO
NEW YORK	N.Y.	NEW YORK	63 BANK ST	

8. MARITAL STATUS (Check one)	9. CITIZEN OF WHAT COUNTRY	10. NAME OF SURVIVING SPOUSE (if wife, give maiden name)
1 ☐ Never Married 2 ☐ Married or Separated 3 ☐ Widowed 4 ☐ Divorced	UNITED Kingdom	

11. DATE OF BIRTH OF DECEDENT	Month Day Year	12. AGE AT LAST BIRTHDAY	IF UNDER 1 year mos. days	IF LESS than 1 Day hrs. min
	MAY 10 1957	21		

13. USUAL OCCUPATION (Kind of work done during most of working lifetime; do not enter retired.)	b. KIND OF BUSINESS	14. SOCIAL SECURITY NO.
MUSICIAN	MUSIC	NONE

15. BIRTHPLACE (State or Foreign Country)	16. OTHER NAME(S) BY WHICH DECEDENT WAS KNOWN
ENGLAND	

17. NAME OF FATHER OF DECEDENT	18. MAIDEN NAME OF MOTHER OF DECEDENT
JoHN RitCHIE	ANNE Mc Donald

19a. NAME OF INFORMANT	b. RELATIONSHIP TO DECEASED	c. ADDRESS (City)
ANNE BEVERLEY	MOTHER	43 SandRingham FLATS, CHARING CROSS Rd LonDon WC2 ENGLAND

20a. NAME OF CEMETERY OR CREMATORY	b. LOCATION (City, Town, State and Country)	c. DATE OF BURIAL OR CREMATION
GARDEN STATE CREM.* No BERGEN N.J.		FEB 7 1979

21a. FUNERAL DIRECTOR	b. ADDRESS
WALTER B Cooke IK.	234 Eighth Ave. N.Y. N.Y.

BUREAU OF VITAL RECORDS DEPARTMENT OF HEALTH THE CITY OF NEW YORK

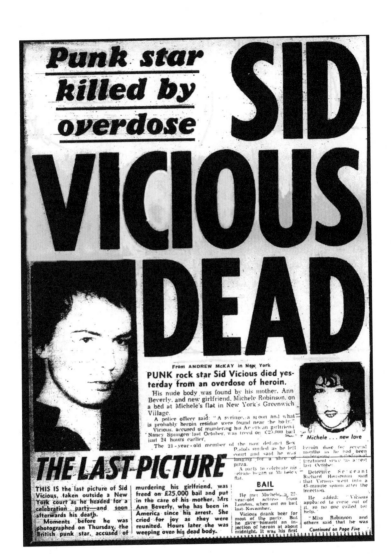

Punk star killed by overdose

SID VICIOUS DEAD

From ANDREW McKAY in New York

PUNK rock star Sid Vicious died yesterday from an overdose of heroin.

His nude body was found by his mother, Ann Beverly, and new girlfriend, Michele Robinson, on a bed at Michele's flat in New York's Greenwich Village.

A police officer said: "A syringe, a spoon and what is probably heroin residue were found near the body." Vicious, accused of murdering his American girlfriend Nancy Spungen last October, was freed on £25,000 bail just 24 hours earlier.

The 21-year-old member of the now defunct Sex Pistols smiled as he left court and said he was longing for a slice of pizza.

A party to celebrate his release began in Michele's flat.

THE LAST PICTURE

THIS IS the last picture of Sid Vicious, taken outside a New York court as he headed for a celebration party—and soon afterwards his death.

Moments before he was photographed on Thursday, the British punk star, accused of murdering his girlfriend, was freed on £25,000 bail and put in the care of his mother, Mrs Ann Beverly, who has been in America since his arrest. She cried for joy as they were reunited. Hours later she was weeping over his dead body.

Michele . . . new love

heroin dose for several months as he had been undergoing a traditional treatment since his arrest last October.

Detective Sergeant Richard Houseman said that Vicious went into a 45-minute spasm after the injection.

He added: "Vicious appeared to come out of it, so no one called for help.

"Miss Robinson and others said that he was

BAIL

He met Michele, a 22-year-old actress from London, when out on bail last November.

Vicious drank beer for most of the party. But he gave himself an injection of heroin at about midnight. It was his first

Continued on Page Five

The short, shocking life of the High Priest of Punk

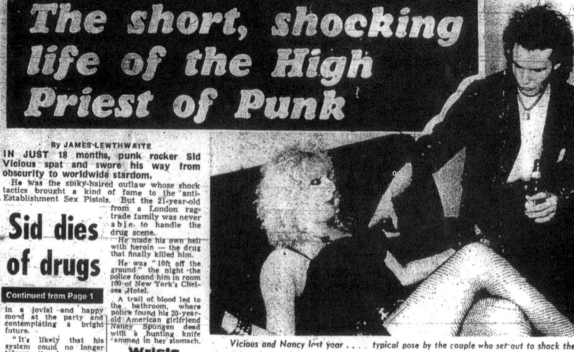

Vicious and Nancy last year typical pose by the couple who set out to shock the w...

By JAMES LEWTHWAITE

IN JUST 18 months, punk rocker Sid Vicious spat and swore his way from obscurity to worldwide stardom.

He was the spiky-haired outlaw whose shock tactics brought a kind of fame to the "anti-Establishment Sex Pistols. But the 21-year-old from a London rag-trade family was never able to handle the drug scene.

He made his own hell with heroin — the drug that finally killed him.

He was "10ft off the ground" the night the police found him in room 100 of New York's Chelsea Hotel.

A trail of blood led to the bathroom, where police found his 20-year-old American girlfriend Nancy Spungen dead with a hunting knife rammed in her stomach.

Sid dies of drugs

Continued from Page 1

in a jovial and happy mood at the party and contemplating a bright future.

"It's likely that his system could no longer tolerate the drug and he died as a consequence."

Vicious—real name John Simon Ritchie — died shortly after 7 o'clock yesterday morning.

His death was discovered when his mother went to Michele's flat to wake the couple.

Another police spokesman said: "He did not intend to kill himself. It was an accident."

Al Clark, spokesman for the Sex Pistols' disc company, Virgin Records, said last night: "I'm concerned that such a tragic accident should have happened when he was seemingly cheerful and looking forward to his freedom."

FRANTIC

Sex Pistols manager Malcolm MacLaren described Vicious's death as "just appalling."

He added: "I'm terribly upset. Sid was in great spirits when he got out of prison. It's a crying shame."

He heard about the death from Vicious's mother who telephoned from New York.

Mr McLaren said: "She sounded frantic. She had just walked into his room and found him dead."

● A Sex Pistols single called "Something Else" —with Vicious singing the lead vocal—is planned for release on February 14. Mr McLaren said: "I assume it will still be released."

Wrists

Shortly after her death Vicious tried to commit suicide by slashing his wrists, telling friends: "I want to die. I want to join Nancy. I didn't keep my part of the bargain."

An American photographer said Vicious told him that there was a suicide pact between them.

But only last week Vicious was dating his new girl friend, bit-part actress Michele Robinson, and predicting he would walk away from the murder charge.

Dark-haired Michele, aged 22, told how nerve-racking it was when she first met Vicious "because people would look at him as if he wasn't human.

"They said 'How can you go around with a guy who kills his girlfriends'?" Michele explained.

His springboard to fame came when Sex Pistols' manager Malcolm McLaren persuaded the giant recording company EMI to invest £40,000 in the controversial group.

Then followed the group's appearance on Thames TV when interviewer Bill Grundy asked them to say something outrageous.

They replied with a string of four-letter obscenities.

But Vicious's outward aggression hid a very weak personality. He needed drugs to keep him going.

When the Sex Pistols began to fall apart last year, Vicious and "Nauseating Nancy," as she was called, tried to become superstars in their own right.

Ended

But Sid was booed off the stage at a New York club . . . and that was the beginning of the end.

The couple retreated into a cloud-cuckoo land of heroin.

VICIOUS is the latest of a long line of stars whose careers have ended in drugs tragedy.

Only last September Keith Moon the "wild man" of pop, died from an overdose—and other victims include Brian Jones, Janis Joplin and Jimi Hendrix.

'THE NIGHT NANCY DIED HURT ME TOO MUCH'

By JOHN LISNERS

I WAS the last person to interview Sid Vicious before he was released from the notorious Riker's Island jail in New York.

Vicious regarded his imprisonment as if he was playing a game of Monopoly with a "get-out-of-jail free" card.

He told me cockily: "They can't keep me here for long.

"I'll be out of here a free man. They haven't got enough on me to stick a murder rap.

"The D.A. (district attorney) will be polishing my boots next week."

He said of Nancy Spungen: "I really loved that girl. She was the only one in the world I ever cared for. I'll never have the same feelings again.

Girls

"In future I'll just use the other girls I meet for sex without ever getting involved with them.

"It hurt too much when Nancy died. I don't know what happened the night she was found dead. I can't remember anything about it. All I know is that I could never do the thing they accused me of."

ON DRUGS, he said: "They took me off drugs for a week in prison and I said I would stay off them. But it won't be too long before I get back on them."

ON DEATH, he said: "I'm going to live life to the full now. I'll take maximum advantage of what life has to offer.

"The last thing I want to do is to kill myself."

Sid's mum, Mrs Beverly . . . she found his body

SEAMY SID

GUITARIST Sid Vicious, the boy from a broken home in London's East End, found love in the bizarre world of punk rock.

Vicious met his girlfriend Nancy Spungen nearly two years ago when he went to America with the Sex Pistols group.

His shows at this time were bizarre. He swore, belched and vomited on stage.

At one concert he bashed a fan over the head with his guitar. "It slipped," he explained.

Vicious liked to inflict wounds on himself with a knife or broken glass.

He would display the scars to audiences.

And then he fell for the blonde from Philadel-

Rocky rise of an East End kid

By ROGER BEAM

phia known as Nauseating Nancy.

Last night friends said the couple seemed made for each other.

"Sid and Nancy were so close," said a spokesman at the Sex Pistols' London office. "He worshipped her."

Vivienne Westwood, girlfriend of the Pistols' manager, Malcolm Mac-Laren, said: "Sid does have a temper, but he loved Nancy very much.

"He and Nancy did have a drugs problem, but Sid was taking a cure course to come off heroin."

Not everyone loved Nancy, though.

Another friend of Vicious described her as

DEAD: Nancy Spungen

a bad influence and added: "She led him on to do crazy things. It was Nancy who got him into drugs.

"She could wind him round her little finger even though they fought a lot.

"But they had a passionate relationship."

SID VICIOUS IN BAIL SHOCK

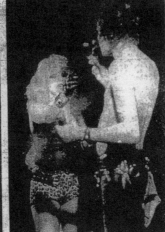

THE FINAL CONCERT

TOGETHER at their last British concert in August . . . punks Sid Vicious and Nancy Spungen. A day later they left on their ill-fated trip to New York.

HELD: Vicious

Star races to find £25,000

From CHRISTOPHER BUCKLAND in New York

SEX Pistol Sid Vicious was trying last night to raise £25,000—the price of freedom.

That was the amount of bail set for Vicious, who is in jail accused of murdering his blonde girlfriend Nancy Spungen.

The 21-year-old punk rock star was shaky and pale - faced yesterday when he was brought to the New York court-room.

He was charged with stabbing Nancy, a 21-year-old go-go dancer, in the bathroom of Manhattan's Chelsea Hotel.

She was found lying in

a pool of blood, wearing only a black bra and panties.

She had been beaten and stabbed in the stomach. A large hunting knife was discovered in the bedroom.

Police said that drug implements, but no drugs, were found in the couple's room.

Last night Vicious was

back behind bars in New York while his supporters led by his manager Malcolm McLaren, tried to raise the bail money.

McLaren flew to New York from London for the hearing and attended said: I'm going to make sure Sid gets the best justice is settle."

If the bail cannot be raised, Vicious is expected to be taken to jail on the notorious Rikers Island off Manhattan until the hearing next Tuesday.

SEAMY WORLD OF DEATH-CHARGE PISTOL — Page 3

Sex Pistol Sid faces murder charge

By KEVIN O'LONE and CHRISTOPHER BUCKLAND

PUNK rocker Sid Vicious was in a New York jail last night—charged with the murder of his American girlfriend.

Vicious, 21, was arrested after the body of Nancy Spungen, clad in only a black bra, was found in their hotel room.

Nancy, a blonde erotic dancer, had stab wounds in her stomach. Detectives handcuffed Vicious and took him to a police station where he was charged in his real name of John Ritchie.

Vicious, former bass guitarist with the notorious Sex Pistols group, and 21-year-old Nancy booked into the £17 per night Hotel Chelsea in Manhattan under the name of Mr. and Mrs. Ritchie.

A spokesman for the New York police department said: "The man will appear in court tomorrow charged with homicide."

Vicious was reported to have raised the alarm by dialling room service, saying "there is something wrong."

Then he rushed downstairs shouting: "Something has happened to my girl."

Horrified hotel staff

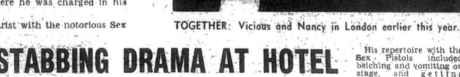

TOGETHER: Vicious and Nancy in London earlier this year.

STABBING DRAMA AT HOTEL

found Nancy's near-naked body lying on a bed. On the floor nearby were two Sex Pistols' golden discs.

Upset

As Vicious was led from the hotel he shouted to the crowd that had gathered: "Why don't you sod off?"

A porter said: "He was in a very upset condition and kept saying: "She's dead, she's dead."

Nancy, from Philadel-phia, met Vicious almost two years ago when the Sex Pistols toured America before their split up.

She was an erotic dancer on the same bill as the group.

Nancy once claimed that Vicious was virtually a virgin when they met and that she had to teach him about sex.

After the Sex Pistol's US tour Vicious and Nancy set up home for a time in London's Maida Vale.

The two landed in trouble earlier this year when they were charged with possessing drugs.

More recently there were rumours that they had secretly married.

Wildest

Vicious, from a broken home in London's East End, has had the reputation of pop's wildest boy.

He has been variously described as "a sewer rat" . . . and just plain obscene.

His repertoire with the Sex Pistols included belching and vomiting on stage, and getting involved in punch-ups.

On their American tour riot police stopped one of the group's shows after Vicious hit a fan over the head with his guitar.

But he once insisted: "I'm not really vicious. I'm kindhearted and I love my mum."

His mother, Mrs. Anne Beverley, of Stoke Newington, London, said last night: "I didn't like his girl.

"I called her nauseating Nancy. She was a bad influence on my Sid."

MY HELL IN A PUNK JAIL BY SID VICIOUS

VICIOUS: On bail.

From CHRIS BUCKLAND in New York

MURDER suspect Sid Vicious walked out of a New York court on £25,000 bail yesterday and said: "It was hell . . ."

He was talking about his four-day stay in a tough New York jail.

The former Sex Pistols star, accused of murdering girl-friend "Nauseating" Nancy Spungen, was mobbed by a curious crowd as he left court after being freed on bail.

The £25,000 bail demanded by the judge was raised by friends—but not before Vicious had spent the weekend in notorious Rikers Island prison.

A rock friend said: "That place is real punk, Sid hated it."

For most of the time Vicious was in a drugs unit being weaned off methadone, a heroin substitute.

Vicious, 21, grinned broadly as he emerged from the courtroom to be met by the jostling sight-seers.

"It's just like the old days," he said.

Judge

He told friends: "Now I'm going to prove my innocence."

Vicious faces a jail sentence of 15 years or more if he is convicted.

The guitarist's mother, Mrs. Anne Beverley, was in court after flying from England for the hearing.

The judge adjourned the hearing until later this month.

Vicious, meanwhile, plans to continue work on a Sex Pistols film and a record album.

Nancy Spungen, a 20-year-old go-go dancer, was found stabbed in the hotel room she shared with Vicious.

She was wearing only black panties and a bra.

Freedom for Sid is a giant ice-cream

PUNK rocker Sid Vicious was finally released from an American jail yesterday.

And the first thing he asked for was a giant ice-cream.

Despite being granted bail of £30,000 two weeks ago, the pop rebel was kept in New York's tough Riker's Island prison because of delay in the cash being transferred from Britain.

But yesterday a Manhattan court ruled that he could be released, provided the security was found by February 16.

The 21-year-old ex-star of the Sex Pistols is accused of murdering his American girlfriend Nancy Spungen last October and of assaulting a musician in a Broadway bar brawl.

Nancy was found stabbed to death in a seedy New York hotel room she shared with Vicious.

But yesterday his lawyer claimed Vicious was acting in self-defence.

From STUART GREIG in New York

test ordered by the court would confirm that Vicious "had been assaulted and had suffered some injuries in that hotel room."

Vicious managed a smile for his mother, Mrs. Ann Beverley, who

RELEASED: Sid Vicious

was in the public gallery sporting a multi-coloured punk hairstyle.

Later, as she waited for her son outside the court, she said:

"The first thing I'm going to do is get him something nice to eat. He wants an enormous ice-cream.

"It's one of the things he really missed in jail."

THE Sun

WHAT'S YOUR SEXUAL AG

See Centre Page

Friday, October 13, 1978 7p TODAY'S TV: PAGES 14 and 15

Handcuffed Sex Pistol led away cursing

SID VICIOU IN MURDER DRAMA

Nancy . . . she was wearing only a bra

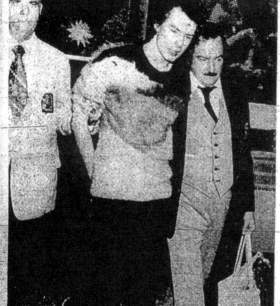

Vicious is led away by two detectives yesterday. **PICTURE BY LOUIS NIGRO**

Girl friend is foun stabbed in hotel room

From LESLIE HINTON
in New York

SEX PISTOLS punk star Sid Vicious was held on suspicion of murder yesterday.

Vicious, aged 21, was led handcuffed and cursing from a New York hotel after his girl friend Nancy Spungen was found stabbed to death there.

Homicide Squad Lieutenant Richard Gallagher said: "He will face a formal charge of murder later."

Hotel staff said police were called after Vicious came downstairs, shouting: "Something has happened to my girl."

Nancy, aged 20, was discovered lying face down in the bathroom with a knife wound in her stomach. She was wearing only a black bra.

A police spokesman said: "He told us that he woke this morning and could not find the girl. He said he found her body in the bathroom and has no idea of what happened."

A lawyer will apply for bail and Vicious plans to deny the charge when he appears in court today.

The couple booked into Manhattan's Chelsea Hotel six weeks ago, as Mr a John Ritchie.

A month aft arrival they from their room when a caught fire.

Manager Stan said: "We welc
Continued on P

THE GROUP THAT SHOCKED THE WORLD—Page N

152 **VICIOUS** TOO FAST TO LIVE

MURDER DRAMA AT HOTEL

Continued from Page One

music. people here. but not his kind. He was trouble—noisy and unpleasant."

Hotel guest Vera Mendelssohn. aged 48. said she heard the dying woman's moans during the night.

EARLY

She said: "I don't know what time it was. very early in the morning I think. I heard this moaning and sobbing from a female voice next door.

"I wish I had called the police. If I had, she might have lived."

Vicious's British manager. Malcolm McLaren. is likely to fly out to New York today.

Mr McLaren said: "I cannot believe he was involved in such a thing.

"Sid was set to marry Nancy in New York. He was very close to her and had quite a passionate affair with her."

Nancy, from Philadelphia, first met Vicious nearly 18 months ago when he was on an American tour with the Sex Pistols and she was an erotic dancer.

A friend said in London last night: "I don't think Nancy was a stripper exactly — but that kind of thing."

Nancy claimed that when she first met Vicious she had to teach him about sex.

She once said: "He was pretty near being a virgin before."

BAD

Vicious's mother. Mrs Anne Beverley of Stoke Newington, London. disliked her. She referred to her as "Nauseating Nancy" and once said: "I think she is a bad influence on Sid. I wish they had never met."

Nancy, who went to a school for problem kids when aged 11. once said: "I'll kill myself as soon as the first wrinkle appears. I don't want to lose my looks."

And Vicious said: "I'll die before I'm very old. I just have that feeling."

● **SHOCKED** residents of Pindock Mews in Maida Vale. North West London. where the couple had a flat for nearly a year. told last night of the "peaceful. polite" punk-rock star and his girlfriend.

Next door. garage owner George Forest. aged 30. said he heard "almost everything" through the paper-thin walls.

He said: "Sid and Nancy were never any bother.

"They had the odd row. like anyone else. but that was very rare."

Mr Forest added: "There was only one real rumpus between them. when Sid threw Nancy out in the middle of the night.

"She was running up and down the mews. dressed only in her G-string. She was yelling 'I love you' through the letter box. sticking her bottom in the air.

"*But she was silenced when Sid threw a bucket of cold water over her.*"

BACK

"Everyone was sticking their heads out of the windows to watch. It was an amazing spectacle.

"Half an hour later. though. Sid let her back in and presumably they made up."

Another neighbour said: "They were rather a weird couple, but they didn't 'cause any aggro.

"I know Sid had a wild-man image on stage, but with Nancy he was rather hermit-like."

'He threw cold water over her'
—Neighbour George Forest

SICK WORLD OF PUNK STAR SID

A violent, swearing drug addict only his mother could love

By DOUGLAS BENCE

SID VICIOUS was a boy only his mother could really love.

Even his fellow punks in the Sex Pistols found his passion for violence and his pathetic enslavement by heroin a bit too much.

The product of a broken home in London's East End, he boasted to all and sundry how much he enjoyed violence.

At concerts he STABBED himself with knives and broken glass.

He SPAT at his audiences—and they loved him for it.

He got into numerous FIGHTS. And he bombarded the world with FOUR-LETTER insults.

But his fans didn't mind. They copied his outrageous language just as they copied his outlandish clothes

School

Like Sid, they wore razor blades as ornaments and bedecked their clothes — and often their ears—with safety pins.

Sid's most controversial record with the Sex Pistols — God Save the Queen in 1977 — was banned by the B.B.C.

It was then that he told the Mirror what he reckoned turned him into a punk rocker —school.

"The teachers taught me nothing," he said.

Sid — real name John Ritchie, would admit to only one weakness. He loved his mother.

He told the Mirror: "I'm not a vicious person really. I'm kind-hearted."

And Mum, Mrs. Ann Beverly, said of him: "His public image isn't justified. He's only violent on the surface."

In two years that violence led to one drug arrest, one murder charge, one suicide attempt — and now his own death.

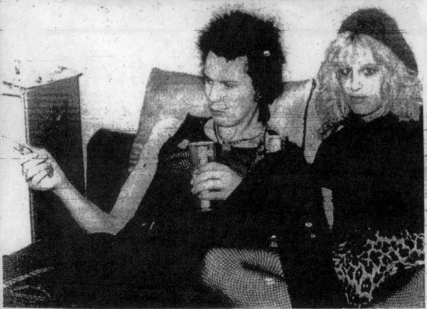

PUNK LOVE: Sid Vicious last year with girlfriend Nancy Spungen and the flick knife she gave him as a present.

Evening News

LONDON: SATURDAY FEBRUARY 3 1979 10p

RACI
MIDD

Drug cure, then overdose

WHY SID VICIOUS DIED

From FRED WEHNER in New York

SID VICIOUS died from a drugs overdose because he had been cured of heroin addiction.

He was found dead in bed with his new girl-friend in her New York apartment after being released from prison on bail.

It was learned today that he had injected himself with his usual dose of heroin at a party to celebrate his release.

But the prison doctors' 55-day detoxification course had cleansed his body to such a degree that the drug acted like neat poison.

The punk rock star suffered an immediate seizure that lasted 45 minutes. Hours later he was dead.

Lost tolerance

New York's chief medical examiner, Dr. Michael Baden, said: " If a drug user detoxifies and then uses the same dose he was accustomed to it can be lethal. The programme takes the user off the drug, but it also removes whatever tolerance or immunity he has.

Sid Vicious : A seizure before death.

" He had taken a shot of whatever he shoots, had lost that tolerance, and he died."

Vicious, real name John Simon Ritchie, was awaiting trial for the murder of girl-friend Nancy Spungen, 20. He also faced an assault charge for a bottle attack on a man in a discotheque in Manhattan.

Today police were piecing together the last hours in his life. On the eve of his death yesterday Vicious had been col-

lected from Rikers Island Prison by his mother, Mrs. Ann Beverley.

She took him straight to the Greenwich Village apartment of his new girl-friend, brunette Michelle Robinson.

Friends were waiting for him to give him a " jail-springing " party. Vicious drank a large amount of beer and then, about midnight he injected the heroin into a vein in his left arm. That took an immediate effect, and he had a seizure. Guests said he seemed to recover about an hour later.

Sgt. Richard Houseman, of Manhattan's 6th Precinct, said: "He went out and returned about 2 a.m., when he and Miss Robinson went to sleep.

"His mother called about noon, and Miss Robinson answered the door-bell. When she returned to the bedroom with his mother they discovered he had died. Then they called the police."

His mother collapsed and was taken to hospital suffering from shock.

Sid's mother . . . Mrs. Ann Beverley.

VICIOUS IN A TRANCE

From LESLIE HINTON
in New York

Sex Pistol is near collapse after 'I didn't stab her' claim

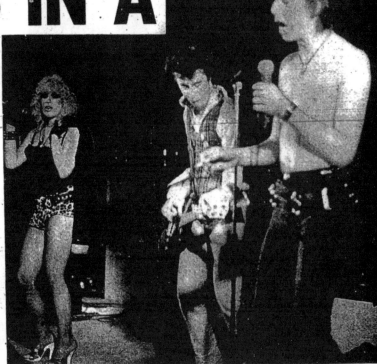

FAREWELL . . . Sid Vicious, right, with Nancy and Glen Matlock on their last London appearance

SEX Pistol Sid Vicious almost collapsed in court yesterday when he was accused of murdering his blonde girlfriend Nancy Spungen.

The 21-year-old spiky-haired punk star seemed to be in a trance as he was led into the New York court by a detective.

Before his appearance, Vicious denied killing Nancy, a 20-year-old American go-go dancer.

His lawyer, Joseph Epstein, contradicted a police claim that the punk rocker had confessed, saying: "There is no basis for that report.".

Staggered

In court, Vicious was helped to a chair as he staggered and buckled at the knees.

His body shuddered periodically as he spent the rest of the 10-minute hearing with his head resting on a table.

Throughout, he seemed oblivious to the proceedings as he was formally charged with murder under his real name, John Simon Ritchie.

If convicted, he faces a prison sentence of 20 years to life.

Judge Martin Erdman set bail at £25,000. He had heard District Attorney Kenneth Schachter say: "No amount of money can guarantee his presence here.

"The case is a strong one with a high likelihood of conviction and a substantial prison sentence to follow.

"The likelihood of him fleeing in these circumstances is great."

Bail

The case was adjourned until next Tuesday and last night Vicious was taken back to prison.

But Sex Pistols manager, Malcolm McLaren, said he would attempt to raise the money to have Vicious freed.

McLaren—who had flown from Britain after hearing of the alleged murder, said: "He is going to get the best possible trial and I am going to try to get him freed.

"The lawyers think, however, that an attempt may be made to increase the amount of bail."

In America, it is not unusual for anyone accused of murder to be given bail.

But one legal device to keep a person accused in custody is to raise bail levels.

Punk rock friends of Vicious sat in court during the hearing.

Singer Jerry Nolan wore earrings made of animal's teeth, a silver skull ring, and brass-studded bracelets.

A toy silver six shooter hung from his studded belt.

Half a dozen other friends with him were dressed similarly.

● IN MOST New York murder cases the defendants are remanded to the city's tough Riker's Island prison.

Al Haber, who works for a city prison aid service, said he would recommend that Vicious be placed in the prison hospital.

He said: "He would run into problems if he was placed with other prisoners at Riker's

"They are rough there and do not like punk rockers."

● STAFF at Manhattan's Chelsea Hotel told yesterday how Nancy's crumpled body was found in a pool of blood in the bathroom of their £16-a-day hotel suite.

Knife

It was discovered by a hotel employee checking on a telephone call to the switchboard reporting that someone in Room 100 was hurt.

"Someone is seriously injured and I'm not kidding, man," said the voice.

Police said they charged Vicious with murder after finding a carving knife in the hotel room.

Vicious . . . on way to court

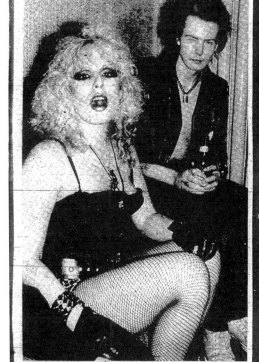

I didn't stab Nancy, says Sid Vicious

—PAGE SEVEN

Vicious: I will miss my Nancy

From LESLIE HINTON
in New York

SEX PISTOL Sid Vicious spoke of his dead girl-friend Nancy Spungen yesterday after being freed on bail.

The punk rocker, who is alleged to have murdered the 20-year-old dancer said: "I'll miss Nancy. She was a great woman. I would like to meet her parents."

Vicious, aged 21, was released from a New York jail after a record company put up £25,000 bail.

Court

He later appeared in court and his case was adjourned until October 30. He denies the charge.

Vicious, who was treated in the prison for drug addiction said: "I feel OK, but now I want to kick the drugs. I am going to do it with no trouble."

PUNK NANCY 'READY TO DIE'

"NAUSEATING" - Nancy Spungen, the girlfriend of punk star Sid Vicious, had a strange premonition that she would die violently.

Twenty-year-old Nancy told her parents: "I'll never make it to twenty-one. I'll go out in a blaze of glory."

That was six weeks ago . . . and yesterday her parents buried her in their home city of Philadelphia. Nancy was found stabbed to death on Thursday in a New York hotel room, and Sid Vicious is now in custody accused of murdering her.

Other people had a premonition that the love of Nancy and Sid was ill-fated.

His manager, Malcolm McLaren, admitted yesterday that once he had been so determined to break up the romance that he and friends had tried to "kidnap" Nancy in London.

"We had a one-way ticket to New York for her," said McLaren.

"But she screamed blue murder in the middle of a street and we had to let her go."

He added: "Nancy was a bad influence on him. He certainly wasn't a heroin addict when he met her."

McLaren is now in New York, still trying to help Sid Vicious, who is in a drug unit.

"I'm determined to get him free on bail before he is sent to the notoriously-tough Riker's Island prison," he said.

"That would be like throwing a baby to the sharks. Sid Vicious is very small and the jail is full of murderers and sex attackers who don't like punks."

Shocked

In another bid to help the star, McLaren has hired private detectives.

"Sid is not clear what happened," he said. "He was shocked when he found Nancy's body.

"It could be that she committed suicide or was murdered by someone else. We just don't know."

Sid Vicious's career had been in decline ever since he split with his group, the Sex Pistols.

But since Nancy's death sales of Sex Pistols records have boomed.

"DOOMED": Nancy

From CHRISTOPHER BUCKLAND
in New York

Pistols may link up again

THE Sex Pistols may get together again to help guitarist Sid Vicious, accused in New York of killing his girl friend.

The punk group's former manager, Malcolm McLaren, said yesterday that an American tour might be organised—with part of the proceeds going to pay for Sid's defence.

The Pistols split up after their last American tour earlier this year.

Vicious, 21, is on £25,000 bail. He is charged with murdering 20-year-old "Nauseating" Nancy Spungen, who was found stabbed to death in their hotel room last week.

Vicious claims the girl was attacked while he was asleep—or that she committed suicide.

If convicted, he faces fifteen or more years in jail.

Meanwhile, plans are going ahead for a Halloween concert by Vicious in Nancy's home

From CHRISTOPHER BUCKLAND
in New York

town of Philadelphia.

If the Sex Pistols do get together again, they may find it hard to be granted US visas.

They were refused entry the last time—then the American government relented.

I WANT JUSTICE FOR MY SID!

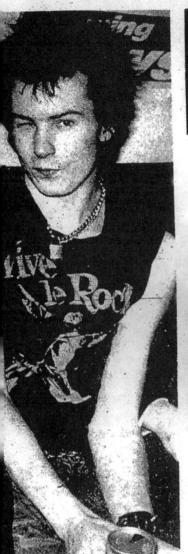

Vicious . . . prison visit from mum



SUN EXCLUSIVE

From LESLIE HINTON in New York

THE mother of punk star Sid Vicious, who is accused of murdering his girlfriend said last night: "I want him to get justice."

Chain-smoking Mrs Ann Beverly, from London, was talking to me exclusively after visiting 21-year-old Vicious in New York's tough Riker's Island Prison.

She said: "He told me. 'I didn't do it, mum.'"

LOVED.

The Sex Pistol told her he found his girlfriend "Nauseating" Nancy Spungen, aged 20, lying on the bathroom floor of their New York hotel room bleeding from a knife wound.

Mrs Beverly added: "She was still breathing and Sid said he shouted at her: 'Nancy, speak to me' Please speak to me'

"When she did not

Mrs Beverly . . . "Sid could never harm that girl."

answer, he ran into the hotel lobby calling for help.

"He is very upset. He loved the girl. He knew he could never harm her.

"He told me he just

does not know how she died or what happened.

"Sid was virtually unconscious. He had been taking some sort of drug.

"The police apparently gave him a hard time. They kept saying. 'Why did you do it' and things like that.'

"He told me he said them: 'If I had done it I would not be standing here, would I' I would have run away.'

Mrs Beverly spent minutes with Vicious in visiting room at the island's hospital wing where he is being given a heroin drug cure.

"When we met we had a hug and a kiss, and

Continued on Page 7

'JUSTICE FOR SID'

Continued from Page One

said: "Hello mum. It's great to see you.'"

Mrs Beverly, aged 46, of Hackney, East London, said friends had rallied round and lent her the money to fly to New York.

She added: "I want to see my Sid gets a fair trial. I have come here to hold his hand.

WEIRD

"What has happened to Nancy is terrible. Sid is definitely going to plead not guilty. Her death is a terrible tragedy.

"She and I never liked each other. He was under the influence of a few weird people.

"Whatever other people think of him, he's my son and right now he needs me."

Vicious has been charged under the name John Simon Ritchie.

"He's always been Simon to me, but he hates the name. When we talk

Nancy . . . she said: " I'll never reach 21."

● IN PHILADELPHIA, Nancy's mother said her daughter told her six weeks ago: "I will never make 21, I will go out in a blaze of glory."

Her parents said she was always highly strung and unable to cope with simple changes in routine.

"There were only one or two people in her life she could really relate to," her mother Deborah

Spungen said. "Sid was one of them."

Vicious and Nancy lived together for 15 months, the longest Nancy had ever stayed with one person, her mother said.

PEACE

Mrs Spungen said Nancy called home a few days before her death to discuss the possibility of her and Vicious entering a drug rehabilitation centre.

"She is at peace, I hope. She was a very special child." Her mother said: "Life is not for special people."

● PRIVATE detectives have been hired to help Vicious, his ex-manager Malcolm McLaren, said.

He added: "We are using them to present the best possible defence case.

"I should know tomorrow whether I have raised the £25,000 needed for Sid's bail.

Vicious is due to face court again tomorrow.

I always call him Sid. It's easier."

Deadly toy of a punk star

SID'S

KNIFE WIELDING: Vicious and Nancy with the knife she gave him—"He was always waving it around."

'Two crazy kids..'

By PETER STEPHENS

THIS is punk rocker Sid Vicious in playful mood with his favourite toy . . . a deadly, razor-sharp flick knife.

It was a gift from murdered girlfriend "Nauseating" Nancy Spungen.

And the Sex Pistols star was obsessed with it. He waved it around at parties—even picked his teeth with it.

And sometimes he would use it in a bizarre game with Nancy — by pretending to slit her throat.

The knife never left his side — until last week, w h e n Vicious was thrown into a New York jail accused of killing Nancy.

The 20-year-old blonde go-go dancer was found stabbed in the hotel room she shared with Vicious.

Last night, Pierre Benain, a friend of Vicious described the wild games the punk pair played. He said: "I often saw Sid and Nancy playing the most sadistic and dangerous games like a couple of crazy kids.

He was always fiddling with the knife Nancy gave him.

But even when he pretended to cut her throat it was only in fun.

I can't believe he killed her. He was so madly in love with her he would never have harmed her.

The trouble with Sid is that he gets terribly bored when he isn't appearing w i t h the group, so he used to drink and take drugs and play stupid games. Nancy was a junkie,

so was he. I don't think she was very good for him. Sid has done some silly things but he is just a lost kid. Not a murderer.

Vicious, who claims an intruder killed Nancy while he slept was still waiting last night for former man ager Malcolm McLaren to raise £25,000 bail. McLaren says he will get the money from British sources—including the Virgin record company.

Vicious is in a drugs centre being cured of heroin addiction.

ICIOUS GAME

ING: Vicious holds the knife to Nancy's throat —"It was a dangerous game, but Sid was only in fun."

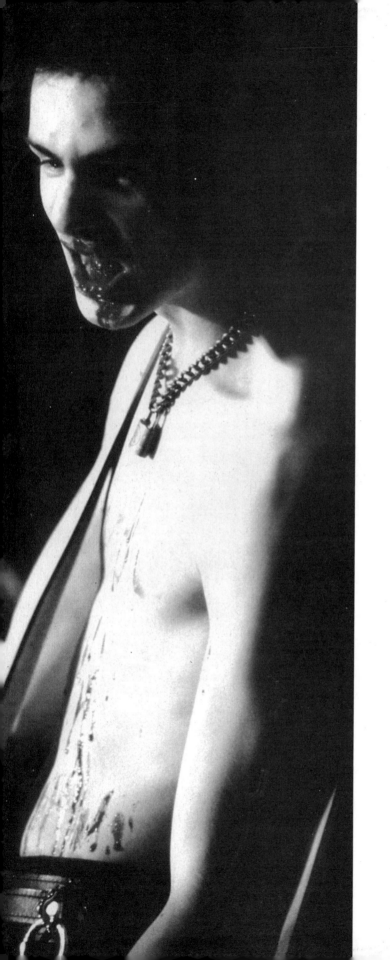

Glitter books